LOST RUSSIA

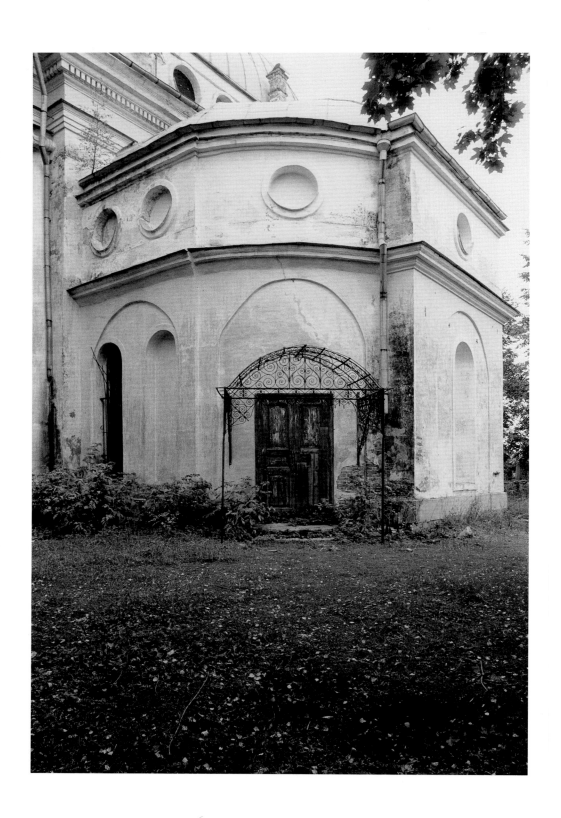

LOST RUSSIA

~

Photographing the Ruins of Russian Architecture

William Craft Brumfield

Duke University Press Durham and London

1995

Library of Congress Cataloging-in-Publication

Data appear on the last printed

page of this book.

Frontispiece: Yaropolets-Chernyshevykh. Church of

the Kazan Icon Mother of God, 1780s.

Research for this book was supported in part by a grant

from the International Research & Exchanges Board (IREX),

with funds provided by the Andrew W. Mellon Foundation,

the National Endowment for the Humanities, and the U.S.

Department of State. None of these organizations is

responsible for the views expressed.

CONTENTS

Maps on pp. 18, 20

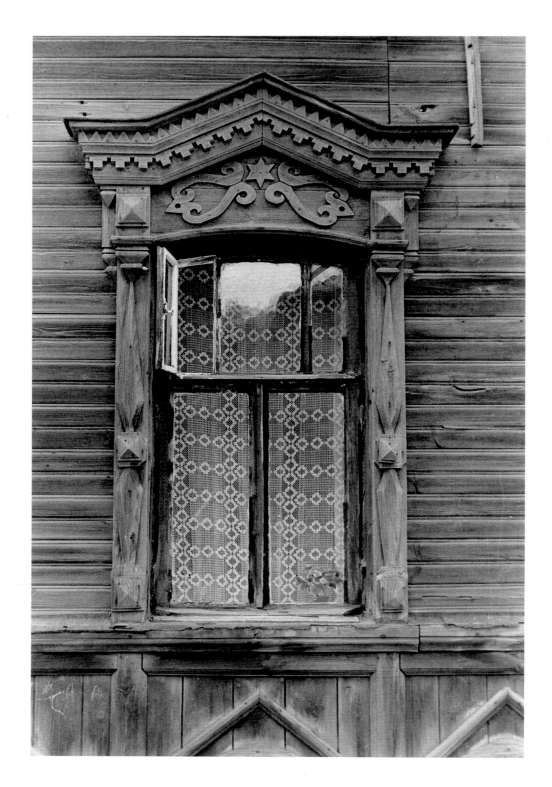

Riazan. Window, 19th-century wooden house.

PREFACE

In choosing the title for this volume, I intended several meanings of the word "lost": neglected, abandoned, forgotten, destroyed. All apply with insistent regularity to much of the Russian countryside. For however hopeful its conclusion, the twentieth century in Russia and its now independent neighbors has been a cataclysm of rare proportions, as wars, revolutions, famine, and massive political terror have tested the limits of human endurance.

One of the most insidious aspects of the Soviet regime, particularly during the Stalinist era, was its calculated attempt to destroy or deform a people's cultural memory. This campaign was implemented with special virulence against religion. The massive destruction of church buildings and religious art resulted in incalculable losses, both in major cities and in the country. Furthermore, masterpieces of Russian secular as well as sacred architecture were heavily damaged in the war zone during 1941–1945. Miraculously, groups of scholars and preservationists managed to salvage and restore much that was threatened by neglect, if not outright demolition. But despite these efforts, time, the elements, and human action (or inaction) continue to take their toll.

Through my work as a photographer and architectural historian in Russia since the early 1970s, I have produced a record of the remaining legacy of Russian architecture, much of which is concentrated in Moscow and St. Petersburg. Perhaps the most poignant rem-

nants, however, are along country byways where abandoned, decaying monuments still retain the builder's original vision with striking clarity. With increased access to provincial Russia, I have attempted to capture in photography the nobility and pathos of these lost monuments, which embody the purity of form and the patterns of ornament that so distinguish Russian architecture.

The purpose of this book, then, is to illuminate Russian culture as reflected in architectural monuments from the heartland, from areas that are not often seen by foreign visitors. On the following pages are photographs of late medieval churches, with severe exteriors and fresco-covered interiors; of neoclassical estate houses and churches from the late eighteenth and nineteenth centuries; of historic Russian provincial towns, which have their own quiet beauty—even in a state of dilapidation, as they usually are; and of Russia's remarkable log architecture. Absent from this book are urban Moscow and St. Petersburg, as well as centers of medieval culture such as Suzdal, Novgorod, and Pskov. All of these have been extensively photographed and discussed in my other works.

Almost all of the photographs herein were taken with a Bronica medium-format camera or with a Nikon FE, of which I carry two, one for color and the other for black-and-white. Ideally, one would have a larger array of equipment for architectural photography, but conditions in Russia are far from ideal, and, in order to convey the range and depth of the country's architecture, mobility is essential. Simply using a tripod—particularly inside a church—can incur the wrath of suspicious citizens conditioned to see all outsiders as potential despoilers. Fortunately, these reactions seem to be on the wane, and I am grateful to those Russians, whether colleagues of long standing or acquaintances of the moment, who have facilitated my work in so many ways.

Despite the long neglect of Russian architecture in Western academia, certain institutions have provided critical support to my efforts as a scholar and photographer. I produced this manuscript in the idyllic North Carolina setting of the National Humanities Cen-

ter, whose staff was unfailingly helpful during my stay there as an NEH Fellow in 1992–1993. In particular I would like to thank Jean Anne Leuchtenburg, editor of the center's journal, *Ideas,* on whose pages some of the ideas for this book first took shape. Similarly, I would like to thank Helene Roberts, editor of *Visual Resources.* For assistance with my black-and-white prints I am grateful to Andrea Gibbs and David Applegate of the Photographic Archives at the National Gallery of Art, which holds the basic collection of my photographs. At the Kennan Institute for Advanced Russian Studies (also in Washington), I am indebted to Blair Ruble and Peggy McInerny for advice and support.

For the production of this book, Duke University Press has received generous grants from the Samuel H. Kress Foundation and from Tulane University. The author is also grateful to the National Humanities Center for organizing the exhibit of my photographs "The Russian Art of Building in Wood," and to Michael Mezzatesta and the Duke University Museum of Art for the exhibit "Lost Russia: Photographing the Ruins of Russian Architecture," to which this volume serves as a partial catalogue.

In my journeys throughout Russia, it has often been my pleasure to have good traveling companions. The most steadfast has been Aleksei Komech, of the Russian Research Institute of Art History in Moscow. My debt to him is incalculable. A number of the photographs in this volume date from the fall of 1992, when I spent a month photographing along the byways of Russia's central provinces. I hope that these images will call forth vivid memories for my frequent companions in that campaign: Priscilla Roosevelt (at work on a study of Russian estate culture), Dmitrii and Katia Shvidkovskii, and our driver, Viktor Pireiko. The images that I saw in this forgotten countryside—tragic, haunting, ineffably beautiful—will be with me forever.

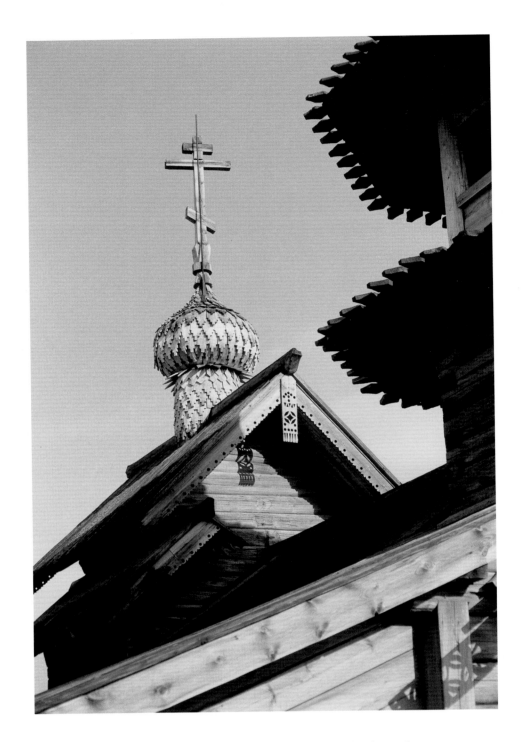

Kizhi. Archangel Michael Chapel, from Lelikozero, mid 18th or 19th century.

DEFINING AN ARCHITECTURAL TRADITION

"The fires and invasions of all preceding epochs were no more destructive for our monuments of antiquity than the indifference to our native past that reigned during the past two centuries."[1] The work of Boris von Eding, who wrote those words in his 1913 guidebook to the medieval city of Rostov Velikii, and that of other Russian historian-preservationists at the turn of the century, indicates that the threat to Russia's architectural heritage was not an invention of Soviet power. In surveying the history of Russian architecture, one is confronted both with the intensity of the Soviet assault on the country's architectural heritage—as a means of deforming its historical and cultural memory—and with the ambivalent attitudes of Russia's pre-revolutionary educated classes toward native architectural traditions. Until relatively late in the nineteenth century, only a few Russians, either devout Orthodox believers or secular intellectuals, knew or cared about maintaining those traditions in any systematic way.

Yet with the growing discussion of issues of national identity in Russia throughout the nineteenth century, historical consciousness found its most tangible expression in traditional Russian architecture (that which antedates the reign of the great Westernizer, Peter I). The nineteenth-century attempt to recover, or create, the history of Russian architecture

had ramifications for the practice of architecture as well as for the study and preservation of medieval monuments. It is this process that alerted a small group of historians (at first little more than amateurs and collectors of antiquities) to the need to save structures that had been altered or damaged with little thought for the cultural value of the past.

Indeed, insofar as most of the structures in question were functioning churches, it could be argued that the issue of their maintenance—and that of their icons and frescoes—was functional, with little intended relation to historic preservation. Therefore, the structure and the art it contained could be modified, overpainted, or even, in the case of icons, discarded in favor of brighter, more recent religious images. Only with the triumph of secular forces in Russian society during the eighteenth and nineteenth centuries could religious artifacts be seen from a detached, historicist perspective that valued them not so much as objects of Orthodox devotion and worship but as representations of an indigenous national past or of folk culture. (One could argue that these monuments became objects of devotion for the secular religion of nationalism, but that does not change the ontological shift in their appraisal.)

Even with the beginnings of patriotic recognition, there remained a deep ambivalence on the part of the Westernized intelligentsia toward the historic buildings, the material remnants of a culture that Peter and his imperial successors had so demonstratively abandoned—particularly in architecture.[2] There could be no clearer statement of this ambivalence than an outburst by the poet Konstantin Batiushkov, who wrote in 1810 that in comparison with Greece and Rome he "would not give a penny for all these Russian antiquities."[3] Nor could one accuse Batiushkov of insensitivity, for he had written with passion and eloquence about the awe-inspiring cityscapes of both Moscow and St. Petersburg.

What, then, was the nature of these "Russian antiquities" that seemed so remote from the classical masterpieces? In fact, medieval Russian architecture had its own classical

lineage, filtered through Byzantium and Orthodox architecture of the Middle Byzantine period. With the acceptance in 988 of Orthodoxy as the official religion among the Eastern Slavs ruled by Prince Vladimir of Kiev, Byzantine master builders followed clerics and artists in establishing the principles of the newly acquired faith and its forms of artistic expression.

The basic, enduring, and remarkably adaptable plan of the Russo-Byzantine church consisted of a cross composed of the main and transverse aisles inscribed within a cuboid core, and a semicylindrical projection (the apse) for the altar in the east. A small church might be limited to that core, but more extensive designs could be achieved by adding flanking aisles. The four piers at the central crossing supported the main drum, or cylinder, and its cupola. Here too, greater complexity could be obtained with subsidiary cupolas (usually four) on flanking bays, yet the tectonic logic of the cuboid core design, with its central drum and cupola, remained clearly in view.

By the eleventh and twelfth centuries, local architectural schools of high distinction had appeared not only in the area around Kiev, but also in distant northern and eastern cities such as Novgorod and Vladimir, which witnessed the construction of numerous masonry churches.[4] Of course, most buildings in the heavily forested areas of Russia proper continued to be built of wood (even including princely residences and many churches). This contrast between towns of wood and churches of stone and brick rendered the plasticity of whitewashed churches all the more impressive.

The Mongol invasion and conquest of Rus in 1237–1241 severely curtailed building activity throughout the area, and over the next two centuries, architects haltingly reestablished techniques necessary for the construction of substantial churches in Novgorod and the emerging grand duchy of Muscovy. After the fall of Constantinople, in 1453, Moscow gradually asserted its status as defender of the Orthodox faith and initiated the construction

of churches of suitably imposing dimensions—above all in the Kremlin. The architects who implemented this leap to excellence were, in fact, Italians, first brought to Muscovy in the 1470s by Grand Prince Ivan III (the Great) and subsequently by his son, Vasilii III, at the beginning of the sixteenth century.[5] Not the least of the Italians' accomplishments was their ability to meld traditional Russian forms—especially the cross-inscribed plan—with a Renaissance understanding of proportion and detail.

Although the Italian architects in Muscovy introduced significant technical skills and stylistic refinements, their Russian counterparts were able to assimilate these elements rapidly and apply them in striking designs, culminating in tower votive churches built during the reigns of Vasilii III and Ivan IV (the Terrible). The most memorable of these structures is the Cathedral of the Intercession on the Moat, popularly known as St. Basil's—built in 1555–1561 to commemorate Ivan the Terrible's conquest of the khanates of Kazan and Astrakhan on the Volga River. Despite the dramatic form of the tower churches, the cross-inscribed plan continued to be used for most masonry churches, large and small, that proliferated in Russia during the sixteenth century.

With the establishment of the Romanov dynasty in 1613 and the recovery of cultural and economic life after the disastrous interregnum known as the "Time of Troubles," influences from the West began slowly penetrating Russian architectural design, particularly in decorative elements. Yet substantial (i.e., masonry) architecture remained largely a matter of church construction. Some significant secular structures existed, primarily for purposes of state, but they demonstrated a very limited view of architectonics as understood in the West following the Renaissance. The churches of this period, however, with their decorative facades and cupolas (often gilded) and bright polychromatic ornamentation, seem to embody the essence of Russianness. Despite the destruction of many of them during the Soviet period, these seventeenth-century churches remain the most pervasive and vivid reminder of a distinctive Russian Orthodox culture in cities such as Moscow and Yaroslavl.

~

After the consolidation of state power under Peter I (the Great) at the beginning of the eighteenth century, the turn toward Western culture accelerated dramatically, in architecture as in so many other areas of Russian life. Engaged in wars—especially against Sweden—during much of his reign, Peter considered architecture an expression of a new political order in Russia, and used the architecture of his new capital, St. Petersburg, as a most visible expression of the transformation. The history of architecture in Russia during the eighteenth century is associated with the importation of Western forms—first the baroque and then neoclassical—whose secular character stood in contrast to the distinctive Russian church designs before the reign of Peter I. But even during this period, tradition continued to play a major role in both architectural form and construction techniques, especially in Moscow and the provinces.

Toward the end of the eighteenth century there began a serious attempt to compile documents and artifacts pertaining to Russian history as embodied in its secular and religious institutions.[6] In describing historic towns and monasteries, a number of the compilers inevitably turned to the histories of their buildings, which by implication were monuments to an authentic Russian past. In 1775 Nikolai Novikov, a leading Russian political philosopher in the manner of the Enlightenment, initiated a periodical entitled *The Treasure of Russian Antiquities,* whose purpose was to resurrect interest in native landmarks. Tellingly, the publication was banned after the first issue because of Catherine the Great's opposition to a secular (historical and artistic) approach to the study of religious monuments.[7]

Throughout the end of the eighteenth and beginning of the nineteenth centuries, however, the predominant architectural style remained neoclassicism, which endowed the capitals of St. Petersburg and Moscow as well as the provinces with some of their greatest architectural monuments—refined and subtle in proportions, yet imposing in form.[8] Although the victory over Napoleon stimulated a further wave of interest in Russian history, culminating with the publication in 1818 of the first eight volumes of Nikolai Karamzin's

History of the Russian State—itself a historical monument of enormous importance—the architects who marked Russia's triumph did so with some of the grandest European neoclassical ensembles, epitomized by Palace Square and Carlo Rossi's Building of the General Staff in St. Petersburg.

Yet even as the completion of the imperial ensembles continued after the death of Alexander I in 1825 and into the reign of Nicholas I, fashion and growing critical opinion dismissed neoclassicism as a sterile, monotonous, and imported style.[9] The search for a new stylistic approach to architecture led in diverse and sometimes contradictory directions usually labeled "eclecticism," which meant that architects were expected to choose among various styles, depending on the needs and wishes of the clients. Most of these styles were related to historical prototypes which represented one aspect of the larger cultural and political phenomenon of nationalism during the early nineteenth century.

In Russia, as elsewhere in Europe, romantic movements for the definition of specific national, ethnic identity gained strength in the wake of the Napoleonic wars; but it could be argued that the tendency was especially strong in Russia, because of collateral issues such as the struggle against serfdom, the persistent tensions between Russia and Poland (then subjugated within the Russian empire), and an awareness of Russia's need for development in order to maintain some form of parity with the more technologically advanced European powers.

These and other factors encouraged Russians to study their traditional architecture both as a source for a distinctively national style in contemporary architecture and as a part of the national patrimony.[10] Indeed, certain architects, such as Fedor Rikhter (d. 1868) and Vladimir Suslov (1857–1920), specialized in the study and restoration of Russian architectural monuments—including, in Suslov's case, log churches. Other architects, such as Vladimir Shervud, Dmitrii and Mikhail Chichagov, and Nikolai Sultanov, created a style,

now known as "pseudo-Russian" or Russian Revival, that imposed elements and motifs from sixteenth- and seventeenth-century church architecture onto contemporary designs for secular structures (museums, theaters, administrative buildings, private mansions) as well as churches.[11]

By the turn of the twentieth century the notion that there existed a distinctive, valuable Russian tradition in design and architecture was widely accepted among architects and the educated public, even as new materials and approaches to structural function shifted urban architecture away from historicist styles. Complementing this process, certain Russian monuments, primarily early medieval churches, benefited from an increasing emphasis on detailed archeological scholarship as a basis for architectural conservation and restoration. Of immense importance in this respect was the appearance of the first five volumes of the *History of Russian Art*, edited by Igor Grabar (1871–1960).

Appropriately, this period witnessed the flourishing of architectural photography, which not only provided the necessary visual documentation to accompany descriptions of architectural monuments, but at its highest level also provided an aesthetic interpretation that affirmed the value of long-neglected structures. In some cases photographers collaborated with historians, an arrangement exemplified by the work of the Rostov photographer Ivan Barshchevskii, whose three thousand negatives of Russian churches taken during the last two decades of the century served as a rich source of material for the preservationist and architect Vladimir Suslov—himself a talented photographer.[12]

Among several other expert photographers who took it upon themselves to record the Russian architectural heritage—particularly in the provinces—were the renowned artist Ivan Bilibin, who produced many of the best photographs of northern wooden architecture for the Grabar *History;* and Sergei Prokudin-Gorskii, who developed a unique process for color photography in 1907 and over the next decade used it, with support of the imperial

7

government, as a means of recording architectural monuments in Russia as well as in other parts of the empire.[13]

For all of the interest in medieval Russian architecture, the beginning of the twentieth century also witnessed the revival of interest in Russia's much maligned neoclassicism, particularly in its later, "Empire" phase from the reign of Alexander I. Maligned as sterile and alien during much of the nineteenth century, neoclassicsm in St. Petersburg, Moscow, and the provinces found defenders who praised its noble aesthetic qualities and lamented its neglect through the sale of estate houses as well as the unregulated growth of the urban environment.[14]

The havoc wreaked by the First World War and ensuing revolutions of 1917 brought most preservation efforts to a halt; yet by odd paradox the anti-religious fervor of the Bolsheviks resulted not only in the widescale destruction and theft of church property, but also, in the case of certain religious works of art whose importance had only been recognized in the preceding few decades (such as the icons of Andrei Rublev), the handing over of objects to museums for preservation. This process in no way justified the Bolsheviks' deliberate vandalism, but it indicated that the secular, art-historical approach to religious art (an approach distrusted by the church at the end of the eighteenth century) had gained the ear of revolutionary leaders, notably Lenin, who issued a decree on the protection of national monuments of art. Such decrees applied not only to objects connected with religious ritual and veneration, but also to church buildings themselves, whose study and conservation was continued in a number of important cases during the 1920s. In central Moscow a number of churches were restored under the auspices of the Central State Restoration Workshops, directed from 1918 through the 1920s by Igor Grabar.

The calculated Bolshevik attack that destroyed so many medieval architectural monuments in the 1930s began tentatively, as various cliques within the Communist party

apparatus probed for opportunities to take advantage of an already weakened church. Although professional restorers in Moscow, for example, temporarily repulsed attempts in the late 1920s to destroy some of the city's most valuable monuments in the historic Kitai-gorod district adjacent to Red Square, by 1930 the onslaught was irreversible. Between 1926 and 1936, in the several square blocks of Kitai gorod alone, ten chapels, seven parish churches (including one of the city's most remarkable late seventeenth-century churches, St. Nicholas the Great Cross), and one monastery cathedral were demolished.[15] Indeed, the massive sixteenth-century wall that surrounded the Kitai-gorod district was also demolished—ostensibly for reasons of traffic control. Other rare examples of Moscow's pre-Petrine secular architecture, such as the Sukharev Tower, were destroyed for the same reason during the same period.

The most famous act of vandalism was the destruction, in 1931, of the Church of Christ the Savior, an enormous structure built from 1839–1883 as a memorial to those Russians who gave their lives in defense of the country against Napoleon. (Contemporary chroniclers of the destruction of Moscow's historic architecture note with asperity that what neither the Tatars nor Napoleon could destroy fell at the hand of Soviet *apparatchiki* and ideologues committed to destroying the country's past in order to create its future.)

The nineteenth-century nihilist political notion that a new order would come only through destruction of the old culture and its symbols moved from the fervent radical imagination into reality as a modus operandi among certain Soviet architects and city planners—bolstered by their interpretation of such modern Western concepts of comprehensive city planning as those of Le Corbusier, who was much taken by the possibilities for Soviet urban renewal during his visits to Moscow in the late 1920s.[16]

The destruction of historical monuments on such a scale cannot, however, be attributed solely to visionary planners or urban design gone awry. It is hardly coincidental that

the most destructive phase of the attack against historical monuments occurred during the implementation of Stalin's cultural revolution, which was in turn inextricably bound with his policy of heavy industrial development and "socialism in one land." Although they comprise only a small part of a much larger tragedy, it must be noted that among those targeted for arrest and death in the Gulag system were preservationists whose attitude toward history was "incorrect."

Yet Stalin was shrewd enough to realize the value of certain architectural symbols for the maintenance of a sense of Russian national identity, increasingly a component of the tendency toward the consolidation of a "conservative" social order that paralleled the growth of totalitarian systems in Europe. Hence, St. Basil's remained untouched—even saved, according to some anecdotes—by the personal intervention of Stalin, who tacitly relished identification with the autocratic politics of Ivan the Terrible. Historical architecture consequently became a most visible symbol of national identity, and the preservation of many monuments associated with the old order (palaces, churches) was mandated by a new elite interested not only in manisfestations of the people's creativity but also in conservative symbols of power and order.

The extent of this new interest in preservation must not be overestimated. A new wave of anti-religious agitation led to futher vandalism during the waning of the Khrushchev era in the early 1960s, a period of political uncertainty that encouraged extremist behavior on the part of some Communist ideological factions. And what deliberate violence did not accomplish, theft and neglect completed in the way of destruction. Therefore, Russia, particularly in the countryside, became a vast network of ruins that symbolized the state's power against and indifference to any culture other than its own.

Today many of those ruins still stand, and although diminished, they retain a power of their own that photography can convey. Photographing these fragments of architecture

from earlier, repudiated cultures need not be a political gesture; it is on one level a documentary method used by art historians since the nineteenth century for the documentation and study of forms and their stylistic development. Yet those who have studied the history of Russian culture are well aware of its ability to place almost any phenomenon in a more radical context, to insist on ultimate categories and the interrelatedness of things. Thus the moral and political dimensions of cultural issues are never far removed. If architecture can symbolize the power of a state and its elite, or the expression of a country's spiritual values, so the destruction of architectural monuments can represent the realignment of power and the negation—or radical reinterpretation—of spiritual and cultural values. The results of this process, the ruins, are visible to those with the knowledge to seek them.

NOTES

1. Boris von Eding, *Rostov Velikii. Uglich*, p. 12.
2. See A. A. Formozov, *Pushkin i drevnosti*, p. 80.
3. K. N. Batiushkov, "Progulka po Moskve." Ironically, the full aesthetic appreciation of St. Petersburg's "Westernized" architectural ensemble would have to wait until the early twentieth century.
4. On the development of architecture in early medieval Rus, see William Craft Brumfield, *A History of Russian Architecture*, part I.
5. The contribution of Italian architects to the revival of Russian church architecture in the late fifteenth and sixteenth centuries is discussed in Brumfield, *A History of Russian Architecture*, part II.
6. On the activities of the early collectors of Russian historical documents, and in particular the circle grouped around N. P. Rumiantsev, see V. P. Kozlov, *Kolumby rossiiskikh drevnostei*. See also A. A. Formozov, "Pervyi russkii."
7. The fate of the periodical, *Sokrovishche rossiiskikh drevnostei*, is discussed in S. Dolgova, "Prodolzhat'."
8. On early nineteenth-century neoclassicism in Russia, see Brumfield, *A History of Russian Architecture*, chapter 12.
9. The more historicism and eclecticism became valued as stylistic features, the harsher the critical comments directed against the imperial design of St. Petersburg and neoclassical architecture generally. See Brumfield, *A History of Russian Architecture*, pp. 389–90, 588.
10. The rise of national sentiment in the historiography of Russian architecture in the nineteenth century is presented in T. A. Slavina, *Issledovateli russkogo zodchestva*, p. 24.

11. On the Russian Revival style, see Brumfield, *The Origins of Modernism*.

12. Slavina, p. 100.

13. Prokudin-Gorskii's work is discussed in Brumfield, "The Color Photographs."

14. On the neoclassical revival in Russian architecture at the beginning of the twentieth century, see Brumfield, "Anti-Modernism and the Neoclassical Revival."

15. The details of the destruction of Kitai gorod, as well as other monuments in Moscow, are now beginning to appear in print. See, for example, Vladimir Kozlov, "Tragediia Kitai-goroda." A more extensive treatment of destroyed monuments throughout central Moscow is Sergei Romaniuk, *Moskva. Utraty*.

16. On Le Corbusier's work and influence on Soviet architecture and urban planning, see Jean-Louis Cohen, *Le Corbusier*.

PHOTOGRAPHING AN ARCHITECTURAL TRADITION

"Russia cannot be grasped with the mind. . . . One can only believe in Russia." These frequently quoted words by the mid-nineteenth century poet Fedor Tiutchev are perhaps the best justification for the work of an architectural photographer in Russia. Not that one approaches this work mindlessly, but even as the characteristics of Russian architecture are related to Western culture, they are in many ways so dissimilar as to elude the usual categories of academic analysis. Photography, perhaps, transmits more of Russia than the mind could otherwise grasp.

My introduction to the country came from a study of its language, literature, and, subsequently, its history. Graduate work in the Slavic Department at the University of California, Berkeley, compelled me to confront Russia for the first time. I realized then that a country existing so richly in the imaginative re-creation of literature and in the lore of the Bay Area community of émigrés ultimately had to be experienced in person. Hence, in the summer of 1970 I set out for ten weeks of advanced language study at Moscow University.

I had no clear idea of what I would see there, but after much deliberation I obtained a sturdy compact camera (my first) and bought two rolls of color slide film. If used judiciously, I reasoned, this would surely be sufficient to record anything of genuine interest—

how much could there be? Despite the limited yield, that summer's rudimentary camera work included two photographs that have since appeared in a number of my publications.

From these tentative beginnings came the realization that Russia was far more complex than I had realized, and that the camera could be an effective means of expressing my comprehension of that culture, of conveying a dimension of understanding beyond the word. On the early trips in the 1970s, I rationalized my fascination with photographing the built environment of Moscow and Leningrad as an adjunct to the study of literary culture, as a setting for works of literature (Dostoyevsky's St. Petersburg the most obvious example).

This simple linkage soon proved unsatisfactory. In the first place the architecture itself deserved far more scholarly attention than I had been prepared to give it. I would learn that astonishingly little had been written on Russian architecture by Western scholars and that academic programs in art history had little or no interest in the topic. Secondly, there was the sheer exhilaration of exploring and photographing an architecture that not only offered a richly varied, often exotic, stylistic display but also had served as a backdrop for some of the most dramatic events of modern European history.

In this respect it was my good fortune to spend my first Russian academic year (1971–1972) in the work of art that is St. Petersburg. An imperial aura surrounded the magnificent architectural ensembles and coexisted with an awareness of appalling sacrifice during the nine-hundred-day siege, the blockade of Leningrad, memories of which still surfaced among a few of the elderly I spoke to. Even the spartan and utterly uninspiring ambiance of our student dormitory on Vasilevsky Island seemed to hint at the slums of *Crime and Punishment*.

In fact our student existence provided a closer insight into the way of life for millions of Soviet citizens: overcrowded communal living, hot water for a few hours one day a week (and only in the building's single shower room), and an apparent indifference to hygiene that enabled one to understand why cholera remained for so long a scourge of Russian

cities. No Westerner who lives in Russia on a level close to that of the ordinary citizen can afford to be very sentimental about the place.

Yet every season had days of startling beauty, when the diffuse northern light washed over St. Petersburg's pastel stuccoed facades, weathered and faded by the elements. One could walk forever without ceasing to be astonished at the very existence of this city, built on a flood-prone, barren northern swamp. It is not without reason that a persona in Dostoyevsky's early work is the strolling observer—or, *flaneur*—for whom St. Petersburg provides an endless source of material on the peculiarity of human existence. In like manner I found myself abandoning the archives for a display of the imperial will in history, immensely evident in buildings by Rastrelli, Rossi, Quarenghi, Zakharov, and so many other architects, foreign and Russian, who added to the magnificent ensemble.

St. Petersburg convinced me that although books beyond counting might exist on the architecture of Western countries, Russian architecture had not been sufficiently photographed and studied as a notable accomplishment of our civilization. If Russian writers, composers, and artists were worthy of intensive, copious study, why should we dismiss a major element in the culture that formed and surrounded them—particularly if that element consisted of an inventive and profound elaboration on architecture ranging from Byzantine to International Modern?

Having been pursuaded visually of this position, I was ready to renew the assault on Moscow, that sprawling, intractable mixture of all cultures and times. Here one might discover a gem of a medieval church at the outskirts of the city, but only after jolting on a spavined bus through a new, faceless megaproject. (It is a telling comment on the Russian sense of scale that these enormous housing developments are known as "microregions.") The aesthetic appeal of St. Petersburg, despite its discomforts, is immediate. Moscow, by contrast, is a hard, gritty town, and the difficulties in photographing architectural monu-

ments within so large an area are compounded by traffic and pollution that have disfigured many of the city's historic districts. In Moscow, as in St. Petersburg, the infrastructure is rapidly and visibly decaying. Yet there are also times in Moscow when the light transforms vistas that rival those of St. Petersburg, when medieval, modern, and neoclassical merge into a congruent image dominated by polychrome decoration and red brick. And Moscow, even more than St. Petersburg, has the research institutions and resources that have been indispensible to the study of Russian architecture.

Although photography has provided the crucial impulse for my publications in architectural history, and for the creation of a Russian architectural collection at the photographic archives of the National Gallery of Art, photography alone could not have sustained that effort over so many years in the face of bureaucratic obstacles and mistrust (especially severe for reasons of international politics in 1979–1980 and 1983–1984). Both scholarly research and the experience of living in Russia have provided a sense of place as well as the specific knowledge of what to look for, where to find it, and why it should be photographed. As for Russian literature, it has always given a resonance to my understanding of the land and its people. To be sure, knowledge of photographic technique has been a prerequisite for my work, but no amount of professional photographic craft can replace the underlying historical knowledge that is essential if photography is to document architecture as an expression of culture.

To photograph what has remained of that culture in architecture, I have returned as frequently as possible not only to the centers of medieval culture (Kiev, Novgorod, Vladimir) and to Moscow and St. Petersburg, but also to the provincial towns and to the great monasteries that served as the outposts of Russia throughout the northern and central forests. The pleasure of traveling in the Russian countryside—whether by bus, train, car, or boat—is an acquired taste; yet even at the rare times when aesthetic interest flags, one is still left with a sense of the past evident in the historical remnants of every town and every country church.

~

Indeed, with the relaxation of travel restrictions, the desirability of surveying the provinces has become irresistable for me. It was in the provinces that so much of eighteenth- and nineteenth-century Russian culture reached its apogee; and despite many decades of neglect that began long before 1917, what remains in the Russian countryside is still evocative of the best produced in a bygone era.

As time and circumstances have allowed, I have made several forays into the Russian heartland, and my trips have provided the material for a number of academic books on the history of Russian architecture. Yet there are advantages to speaking of what I have observed in a more direct way, without the assumed detachment of academic history. This is particularly true in Russia, where the condition of buildings (or their ruins) can be read as a sign of fundamental transformations in a society. It is difficult to speak of this other level of comprehending Russian architecture without providing a commentary on the very act of photographing. The following notes will attempt to do that on the basis of impressions from a number of my journeys.

The most intensive of these explorations of the provinces occurred in late September 1992, when I was able to document and study architectural monuments in the provinces surrounding Moscow. The primary goal was the large area of Moscow *oblast,* including towns such as Volokolamsk, Mozhaisk, Podolsk, Kolomna, Serpukhov, and Borovsk. More distant, overnight trips were arranged to Kaluga, Viazma, Tula, Bogoroditsk, Rostov, Iaroslavl, and Tutaev, with forays into the countryside around all of these cities. One of the farthest points was the Turgenev estate at Spasskoe-Lutovinovo, just a few kilometers to the east of Orel. Although most of these sites were within a three hundred-kilometer radius of Moscow, access would in many cases have been difficult or prohibited in past years. My sponsor, the Moscow Architectural Institute, assisted in defining trip itineraries in consultation with specialists there and at the Russian Institute of Art History. None of my requests was refused.

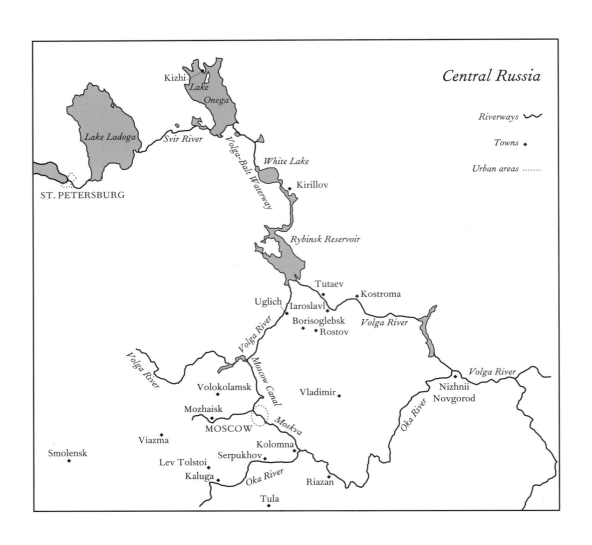

Central Russia

Kizhi
Lake Onega

Lake Ladoga

Svir River

Volga–Balt Waterway

White Lake

Kirillov

ST. PETERSBURG

Riverways

Towns

Urban areas

Rybinsk Reservoir

Tutaev

Kostroma

Uglich

Iaroslavl

Borisoglebsk

Rostov

Volga River

Volga River

Volga River

Volga River

Oka River

Nizhnii Novgorod

Vladimir

Volokolamsk

Moscow Canal

Mozhaisk

MOSCOW

Moskva

Viazma

Kolomna

Smolensk

Serpukhov

Lev Tolstoi

Oka River

Riazan

Kaluga

Tula

INTO THE PROVINCES

Getting there: the essential substance for our Russian Fiat clone was ninety-three octane gasoline, sporadically available after a wait that typically lasted three to four hours for a private car. Viktor Pireiko, the retired journalist who was our driver, undertook this task with exemplary good grace in the evenings as he read the day's press. At three times the regular state price, one could purchase gasoline more quickly from a private speculator (when such was available), and after a long day or in areas of acute gasoline shortages, that option was readily used. There are now a few foreign stations in Moscow that accept only hard currency, with little or no wait.

The condition of the roads in central Russia varies greatly, but the main arteries out of Moscow are four-laned and well paved—up to a point. Even some of the back country roads are good; but others are execrable, jolting tracks that may or may not have a makeshift bed of precast concrete slabs. Such roads are dangerous, and if not negotiated with care, can cause serious damage to the car in an area that has few, if any, repair facilities. But an experienced Russian driver can tell whether the risk is worth taking; and if it leads to the right church or estate house, a way can be found.

But in the maze of Russia's backcountry roads, the right way is often elusive. Although Russian maps are less deliberately misleading now, reliable information on the loca-

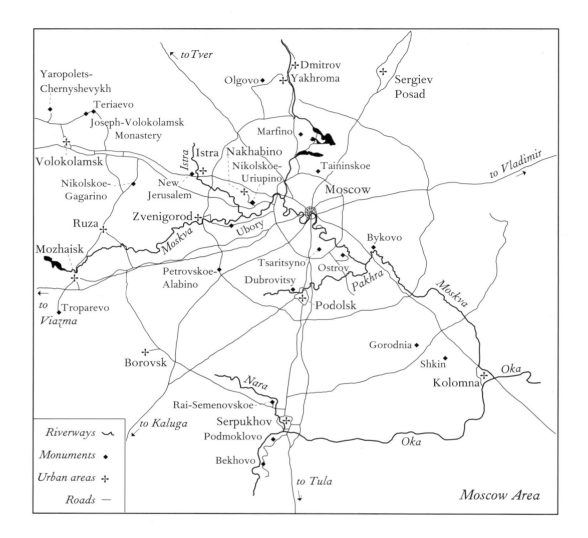

Moscow Area

tion and condition of local roads is still difficult to obtain, short of asking the nearest by-standers. For Moscow *oblast* there is also an excellent two-volume guide to architectural sites; but its information and photographs, although valuable from a historical perspective, give little indication of the current condition of the buildings, which often prove to be in an advanced state of dilapidation. When the road leads to ruins of a monument, there descends a haunting sense of disappointment.

The situation is especially precarious for eighteenth- and nineteenth-century estate houses without a reliable institutional sponsor. Brick churches, even when gutted and stripped,

were so solidly built as to withstand anything less than a major explosion, as exemplified by the proud, desolate neoclassical Church of the Intercession at the village of Andreevskoe (1803; figure 1), north of Moscow. But when the roof of a house is neglected, the interior work rapidly decays and with it adjacent support structures, until only fragments of the walls and cellar vaults are left, a process that was strikingly evident at the Olgovo manor (figure 2), farther along the road that goes past Andreevskoe. This masterpiece of late eighteenth-century design remained relatively intact in the 1960s, but is now an outline of ruins adjacent to a tourist colony.

Fortunately, the autumn of 1992 was one of the most beautiful in recent memory, and there were days when the sun cast an elegiac glow on the spectacle of neglect. Indeed, not all was abandoned: some of the old estate houses are reasonably maintained—at least structurally—and a very few are restored as museums. Many churches have reopened as houses of worship, some monasteries and convents have returned to active status, and in all of these instances, repairs are under way with obvious, often dramatic, results. It would be premature to characterize these efforts as a renewal of culture in the long-impoverished Russian countryside. Yet the noticeable contrast in conditions over the space of a few years and the possibilities of hope, as well as the presence of economic hardships, lend these provincial areas of central Russia a special interest and poignancy.

This Russian heartland extends in all directions from Moscow, including the roads formerly taken by visitors, or intruders, from the West. In a northwesterly direction, toward the Baltic port of Riga, an excellent superhighway now extends as far as the medieval city of Volokolamsk (118 kilometers from Moscow), where it abruptly changes to a two-lane road of uncertain quality. Much of the center dates from the nineteenth century, yet Volokolamsk has retained its ancient Cathedral of the Resurrection (figure 3), originally constructed in the late fifteenth century by Prince Boris Vasilievich Volotskii. The cathedral was frequently rebuilt, and its extant walls contain layers from the fifteenth to the seven-

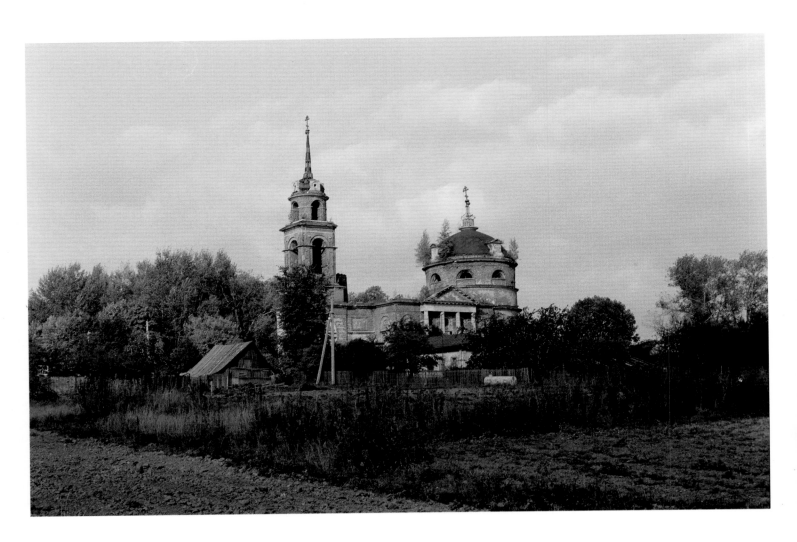

Figure 1. Andreevskoe. Church of the Intercession, 1803.

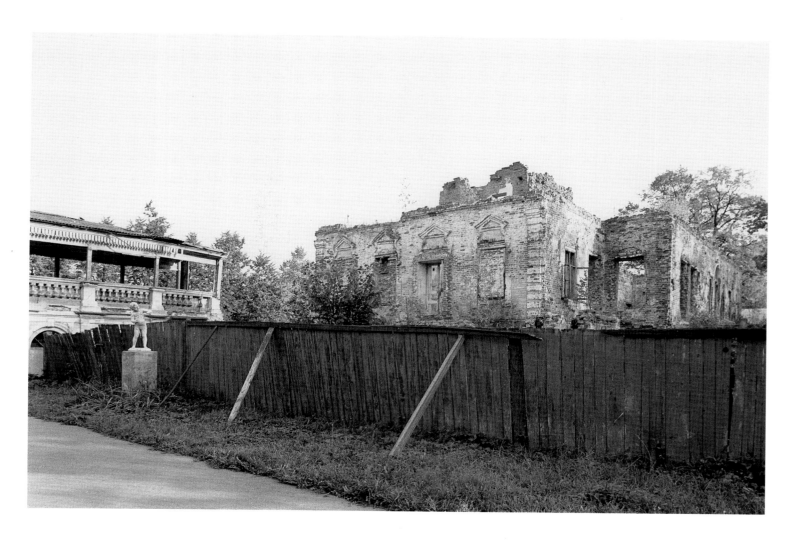

Figure 2. Olgovo. Estate house ruins, late 18th century.

∿

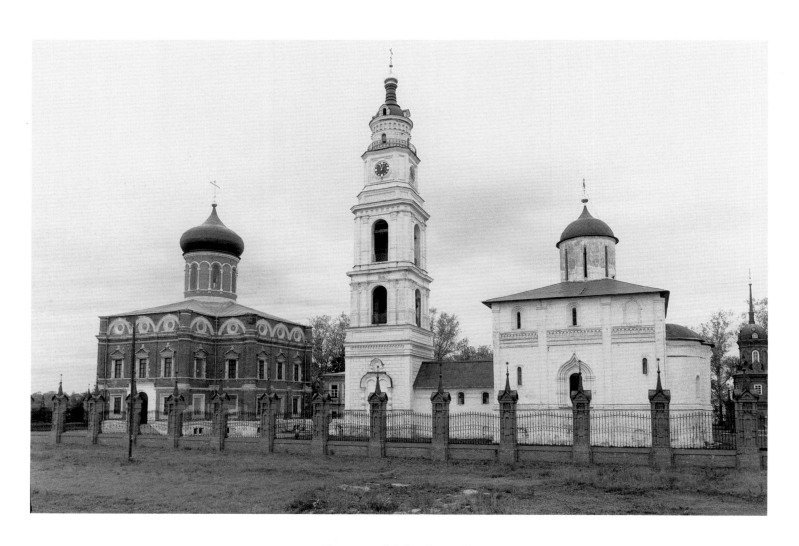

Figure 3. Volokolamsk Kremlin.

24

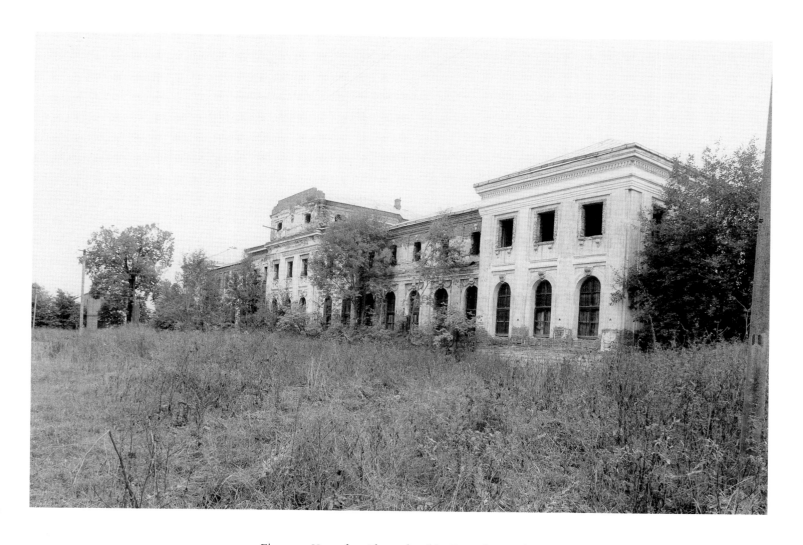

Figure 4. Yaropolets-Chernyshevykh. Estate house ruins.

∾

teenth centuries. Some conservation efforts are evident, but the interior of the cathedral is still a massive ruin. The ensemble includes a bell tower, connected to the west facade of the cathedral at the end of the eighteenth century, and a ponderous late nineteenth-century brick church in a historicist style of mixed antecedents.

The Volokolamsk area, like others west of Moscow, was the scene of major battles in the fall of 1941. Although the battle lines moved quickly, major losses were inevitable. The impact of war damage, combined with neglect and vandalism, is especially noticeable at the estate of Yaropolets-Chernyshevykh, near Volokolamsk. The Chernyshev mansion (figure 4) was begun in the 1760s for Zakharii Chernyshev, a prominent courtier during the reigns of Elizabeth and Catherine the Great. During the Seven Years War, Chernyshev achieved the rank of general, and in October 1760 his troops stormed and occupied Berlin. Although relatively intact at the beginning of this century, the Chernyshev mansion was gutted during the Second World War. Inept attempts at restoration have since left it with little more than shattered walls.

Across the road from the Chernyshev mansion stand the imposing twin chambers of Church of the Kazan Icon of the Mother of God (figure 5), built to idiosyncratic design in the 1780s. The eastern part of the structure served as the church proper, while the western half contained the Chernyshev burial chapel. According to a local resident, the church was still in reasonable condition and used for services before being closed and eventually vandalized during the anti-religious campaigns of the early 1960s. Its icons plundered and windows broken, the church has since noticeably deteriorated. It is now surrounded by apple orchards, and sheep safely graze within its shadow.

Such histories could be repeated for numerous other estate complexes, yet this area also contains one of the most successful contemporary restoration efforts in Russia: the Joseph-Volokolamsk Monastery at the village of Teriaevo, near Volokolamsk. The monas-

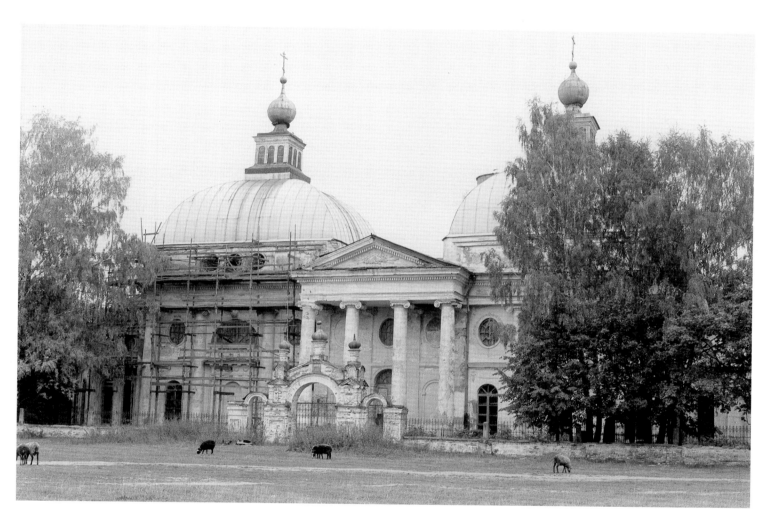

Figure 5. Yaropolets-Chernyshevykh. Church of the Kazan Icon Mother of God, south view, 1780s.

tery was founded in 1479 by Joseph Volotskii, a prominent cleric who vigorously defended the prerogatives of the church and its monasteries in accumulating wealth. No doubt he would have been pleased with this magnificent walled complex (figure 6), which dates primarily from the great age of Russian monastic construction in the latter half of the seventeenth century.

The ensemble was particularly impressive when viewed across the pond along its south and east walls in the soft light of an October afternoon. The presence of a pond, natural or artificial, was a frequent feature of Russian monastery ensembles, which used the environment to enhance or reflect architecture to stunning visual effect. The reflection of the monastery in the pond suggests the union of elements, the merging of heaven and earth, and legends of the "invisible city." Until the Second World War an octagonal bell tower rose above the middle of the Joseph-Volokolamsk Monastery, but in the fall of 1941 this potential observation tower was demolished by the retreating Soviet army with little damage to the adjacent Cathedral of the Dormition.

The interior of the Dormition Cathedral, with its late seventeenth-century iconostasis and frescoes (figure 7), is one of the most impressive examples of monastic design and is in unusually good condition—perhaps a result of the influence of the monastery's recent benefactor, Metropolitan Pitirim of Volokolamsk. Not only are the churches, walls, and towers of Joseph-Volokolamsk Monastery impressively restored, but this functioning monastery also contains the new Museum of the Bible, sponsor of a program to publish in facsimile edition a medieval Russian Bible, with scholarly annotation. Before I photographed the interior of the monastery, the abbott discussed the activities of the museum. Although he modestly insisted on the distinction between theology and science, it was clear that such work represents a return to the traditional cultural function of large monasteries as centers of learning. Restoration work is in progress, supported in part by donations from a German

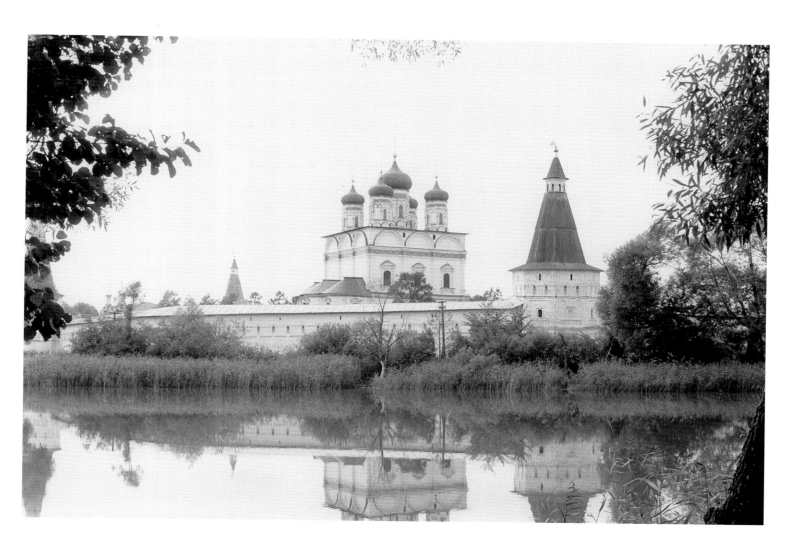

Figure 6. Joseph-Volokolamsk Monastery, east view, 17th century.

∿

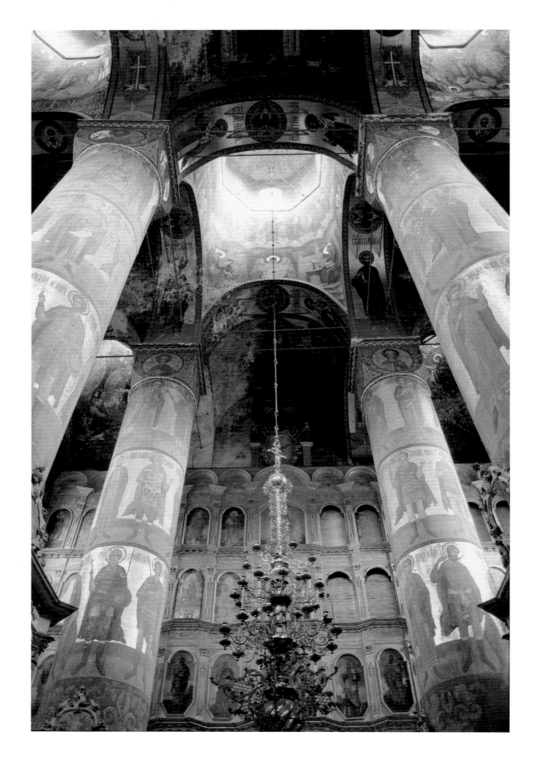

Figure 7. Joseph-Volokolamsk Monastery. Dormition Cathedral, interior, east view, 1690s.

charitable institution. A construction detachment lives on the premises and uses part of the enclosed space for a vegetable garden.

Returning to Moscow with the fading light, we decided to chance on one more site: the estate house at Nikolskoe-Gagarino (1774–1776), now a children's psychiatric hospital (figure 8). Again and again in the countryside around Moscow one comes across historical monuments that have been converted for use as clinics or asylums of various sorts. There is a strange and elusive significance in all of this. Both preservation and patients would be better served were there the resources to build appropriate sanatoriums; yet in lieu of these resources, an abandoned neoclassical estate house or church complex might provide a more humane environment than an unadorned institutional barracks. The thought of the decaying architecture of a lost world serving lost souls suggests a link with the Russian fascination with the work of William Faulkner and other writers from the American South, whose own settings bear a resemblance to these abandoned Russian sites.

To come to Nikolskoe-Gagarino in the twilight was an unsettling experience, but in retrospect, I am convinced that it was worth the effort. For our driver Viktor, however, it was a big mistake: unfamiliar with the country distances, he ran short of fuel. With sinking hopes and indicator on empty, we again reached the expressway and made it to a militia checkpoint, where Viktor explained our situation. The weary militia officers were unimpressed ("Let the Americans see how we live," I understood one of them to say), yet they obliged by stopping a few drivers, one of whom finally offered some seventy-six octane fuel for a suitably inflated price. The engine knocked most of the way back to Moscow, and Viktor's wife was understandably upset by our late arrival.

To the south of the Volokolamsk highway, the rolling landscape grows softer and more inviting, particularly along the western reaches of the Moscow and Istra Rivers. This

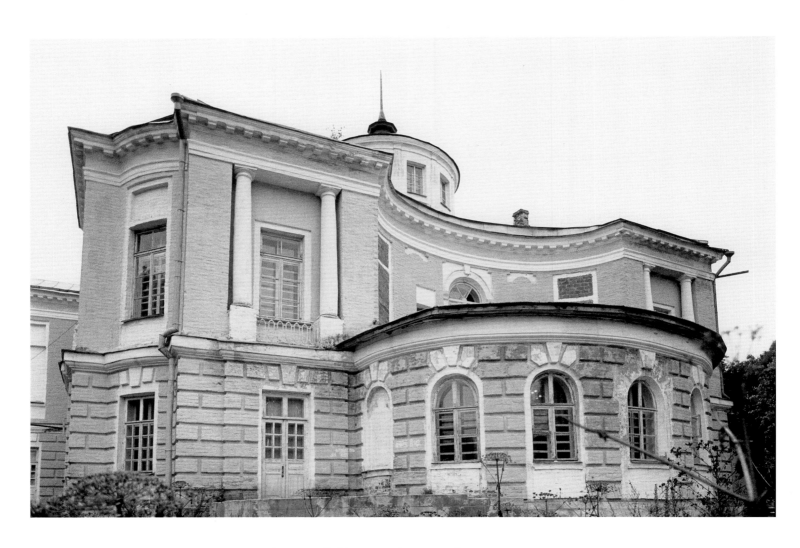

Figure 8. Nikolskoe-Gagarino. Estate house, 1774–1776.

area contains one of the richest concentrations of extant country estates, beginning with the lavish Yusupov ensemble at Arkhangelskoe (dating from the early nineteenth century and now under interminable restoration). Most of the estate houses have long vanished, but a few of the estate churches remain, such as the Transfiguration of the Savior at Ubory (1694–1697; figure 9), whose towering form of red stuccoed brick overlooks the marshes of the Moscow River. The design of this church and its decoration exemplify a Westernizing trend adopted by grandees such as the Sheremetevs (who owned Ubory) in the early reign of Peter the Great. After many years under restoration, this church, a major landmark of seventeenth-century Russian architecture, emerged from its rot-blackened scaffolding in a pale image of its former glory. Although panes of glass are still broken, the interior is clean, and the noble clarity of its lines is unobstructed and well illuminated by natural light. In October 1992, one icon hung on the bare white walls; a makeshift sign announced occasional services by a priest from a neighboring church.

Wandering along country roads back from the river, one can find more peculiar hybrids, like the Church of St. Nicholas at Nikolo-Uriupino (1664–1665; figure 10), whose flanking chapels and gables suggest an earlier, sixteenth-century style. This church, too, had been restored, but no community had yet claimed it, and signs of neglect were everywhere, including the coating of dust from a heavily traveled dirt road. The wooded location might be very picturesque if the road were paved and the neighboring, late eighteenth-century estate house and pavilions were restored.

As it turned out, Nikolo-Uriupino was partly on the grounds of a military training base, through which the only paved road to the highway leading to our next destination lay. Rather than risk the dirt road, or backtrack and lose precious October daylight, our intrepid driver drove up to the main gate, got out, and began quietly talking to the young soldier on duty. Among the few words I could hear were "American reporters"—it being Viktor's

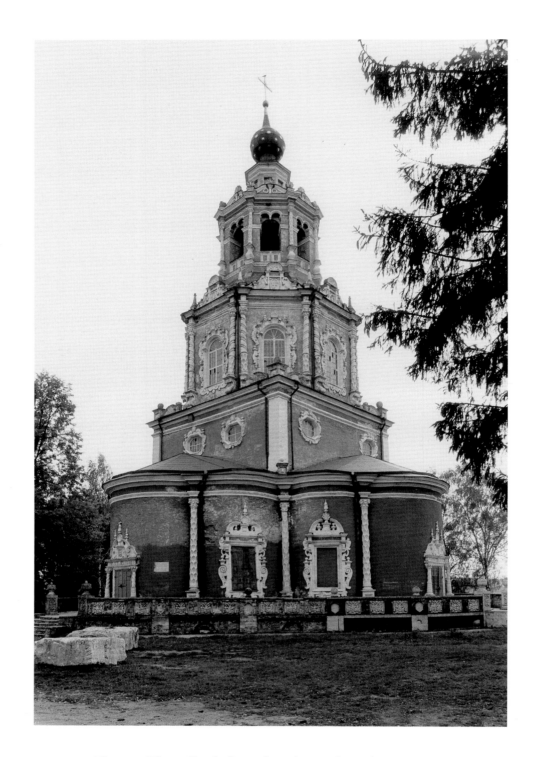

Figure 9. Ubory. Church of Transfiguration, northwest view, 1694–1697.

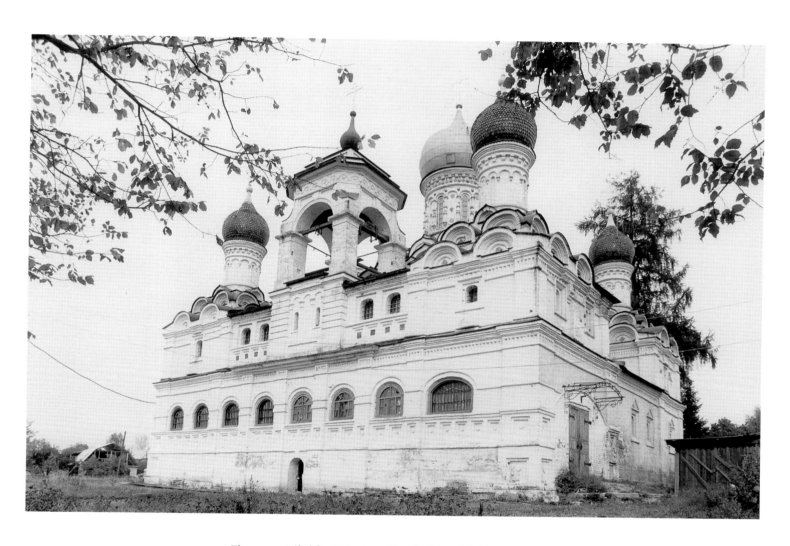

Figure 10. Nikolsko-Uriupino. Church of St. Nicholas, 1664–1665.

opinion that the way to impress his countrymen with the urgency of our search for lost Russian architecture was immediately to declare the American identity.

Remembering a far different political atmosphere and not quite believing that no one cared now whether I had an internal visa, I shrank from such "explanations" to soldiers of stern demeanor. To my surprise Viktor soon returned and said that we could go through. The price of admission: one American cigarette, which the guard with practiced movement slipped up his coat sleeve. The pine wooded base faintly resembled an abandoned amusement park, with signs pointing to firing ranges, warehouses, and other sites that I paid little attention to. Few people were around, and to confirm that we were headed toward the exit, we flagged down a passing civilian car with officers in fatigues. Directions were courteously confirmed, and after a few more kilometers of forest, we reached the exit gate and were passed through without a word. Despite the mention of the benign word "American," it was advantageous in such encounters to be in a car with ordinary Russian license plates.

After passing through the industrial blight of Nakhabino, we turned onto the highway to Istra (fifty-eight kilometers from Moscow), located on the river of the same name and site of one of Russia's most unusual monastic complexes: the Resurrection Monastery at New Jerusalem (figure 11). The monastery was founded in the mid-seventeenth century by Patriarch Nikon, who undertook a divisive, if well-intentioned, attempt to reform certain religious texts and practices, and created this magnificent ensemble as a symbol of his authority within both church and state. Indeed, the very name and dedication of the monastery are among the last messianic notes sounded in medieval Russian culture. Based on the design of the Church of the Resurrection at the Holy Sepulchre in Jerusalem, the Cathedral of the Resurrection at New Jerusalem (figures 12, 13) evolved over several stages, the first of which began in 1656 and ended in 1666, after Nikon's fall from favor and exile to the far north. Construction resumed in 1679 under Tsar Fedor Alekseevich, and was completed in

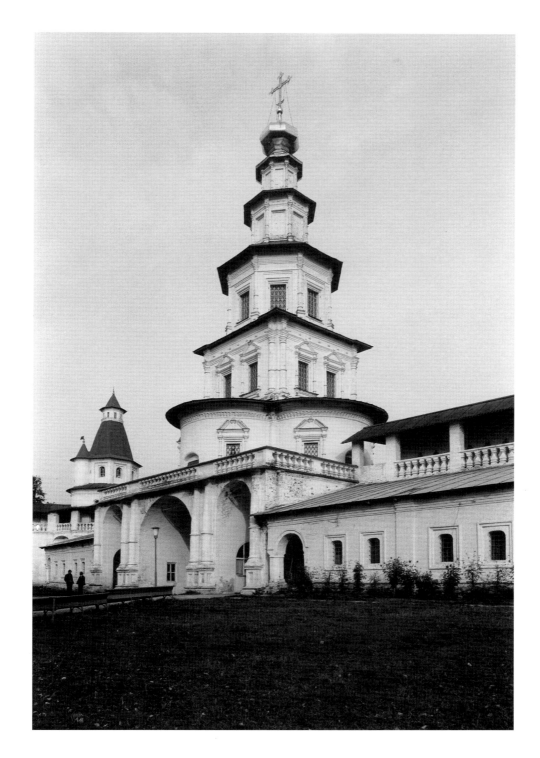

Figure 11. New Jerusalem, Resurrection Monastery. Gate Church of Entry into Jerusalem. 1690–1694.

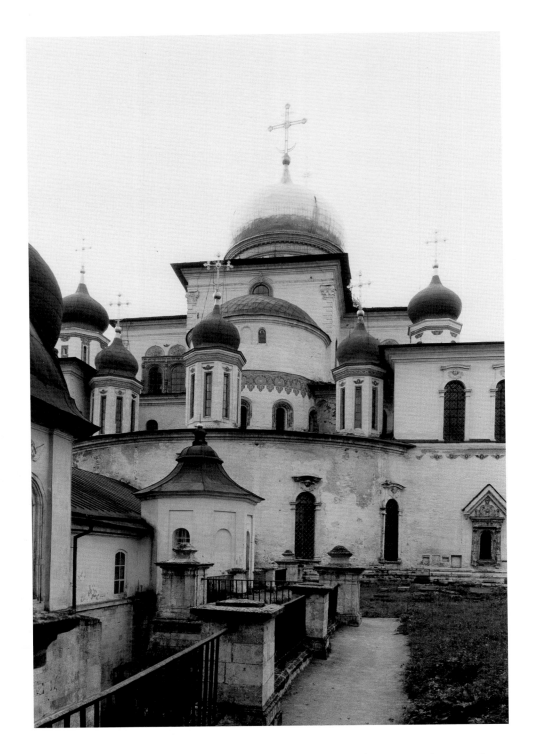

Figure 12. New Jerusalem, Resurrection Monastery. Cathedral of the Resurrection, east view.

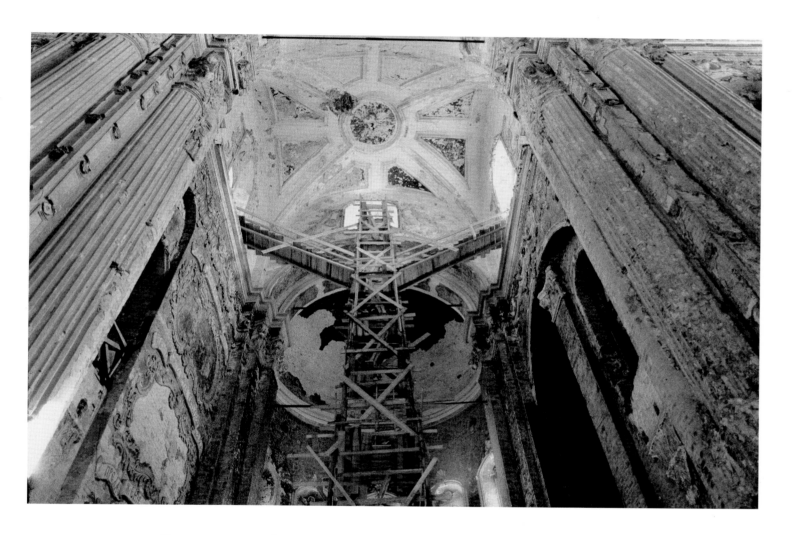

Figure 13. New Jerusalem, Resurrection Monastery. Cathedral of the Resurrection, interior view

(church is undergoing reconstruction).

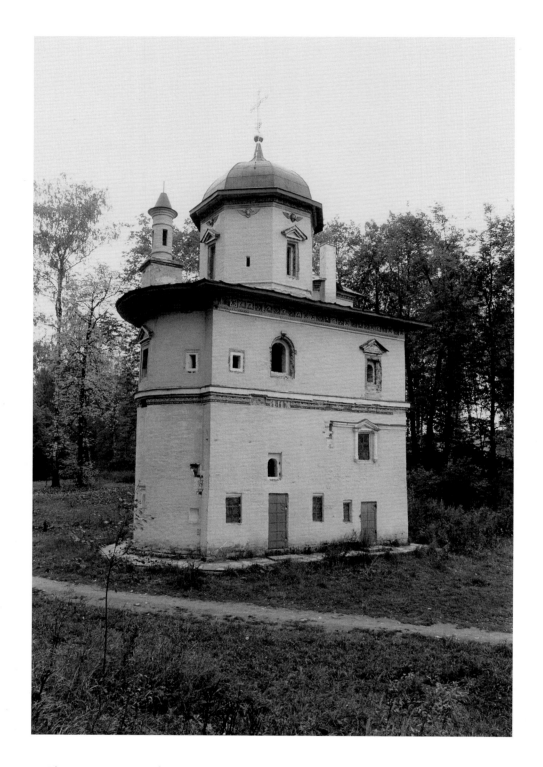

Figure 14. New Jerusalem, Resurrection Monastery. Skete (retreat) of Patriarch Nikon, 1658.

1685. In 1723 the brick, conical roof over the enormous rotunda collapsed, and in 1756–1761 Karl Blank erected a wooden roof of similar form. During the same period, Bartolomeo Rastrelli, the master of the imperial baroque style in St. Petersburg, created the elaborate baroque interior decoration for the rotunda. Almost all of this work was lost during the retreat of the German army from Moscow in the autumn of 1941: demolition charges were exploded under the massive western piers and brought down most of the main structure. After a botched attempt to restore the dome in the late 1970s, the exterior is finally reaching completion. Restoration of the interior remains a daunting, and perhaps never to be completed, task. In counterpoint to the majestic proportions of the cathedral is the architectural fantasy of Nikon's personal retreat (or *skete;* figure 14) and chapel, in a glade beyond the monastery's west wall.

Fantastic forms and colors are brilliantly represented in other monasteries and medieval estate churches just south of the Istra and Moscow Rivers. The ancient town of Zvenigorod contains one of the richest examples, the St. Savva-Storozhevskii Monastery (figure 15), whose ensemble of churches and towers, dating primarily from the seventeenth century, is in the final prolonged stages of restoration. The evening light is particularly lambent on the colors and textures of these stuccoed brick forms.

The best known route of travelers and invaders from the west is the road from Smolensk, which passes through Viazma and Mozhaisk. Smolensk has been much changed by the vicissitudes of time and violent history, but miraculously, some of Russia's most peculiar church architecture has survived in Viazma, despite the fact that the entire area was the scene of horrific battles from the fall of 1941 until its liberation early in 1943. Flush with victory after repulsing the Germans before Moscow in the winter of 1941–1942, the Red Army attempted to gain and hold Viazma with too few resources in 1942. The consequences

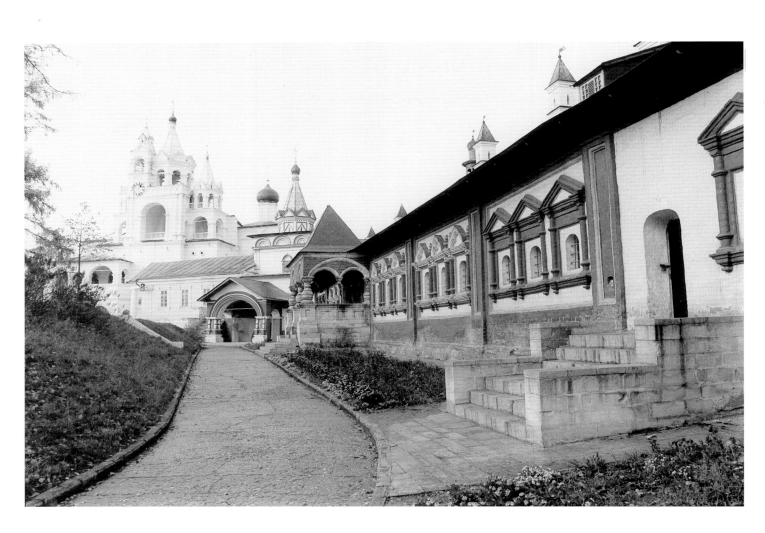

Figure 15. Zvenigorod. St. Savva-Storozhevskii Monastery, 16th–17th centuries.

were disastrous for those elements of the army that could not break out of encirclement toward the east, and most of the town was destroyed.

When one speaks to residents of Viazma today, it is clear that those battles remain in memory; yet those who care about such things will also tell you that most of the damage to the churches came primarily from the Communists in the 1930s. This is not said in justification of the invaders, but as a fact long tacitly understood. The late eighteenth-century Church of St. Catherine—built on the site of a plague burial ground, as were most churches dedicated to Catherine during that period—has long stood as an empty shell (figure 16). I was told that during the occupation, its icons were taken to a different church, reopened for worship. St. Catherine's is now venerated by those visiting the cemetery, who approach the portal and make the sign of the cross. The recently cleaned interior has a haunting power, with its dirt floors and spacious bare walls and vaults (figure 17).

The most striking of the Viazma churches, however, is the one dedicated to the Hodigitria Icon (1635-1638) at the Monastery of John the Baptist. Founded in 1536, the monastery has undergone the many trials of this frequently invaded land: it was burned by Polish detachments during the Time of Troubles in the early seventeenth century; rebuilt in the 1630s with a donation from Tsar Mikhail Fedorovich (the first Romanov tsar); burned again during the Napoleonic invasion of 1812; repaired in 1832–1836; closed after the bolshevik revolution; and further damaged during the Second World War. Nonetheless, the land's seventeenth-century churches were built so well that they remain structurally sound. This is particularly evident at the Hodigitria Church, with its massive brick base and three towers, now in the final stages of restoration (figure 18). Perhaps this exuberant design represents a beacon, as its dedication suggests, or perhaps it commemorates resistance to invaders, as do other tower churches built in Muscovy following the Time of Troubles. The monastery seemed uninhabited apart from a portly, bearded monk in charge of the refectory and Church

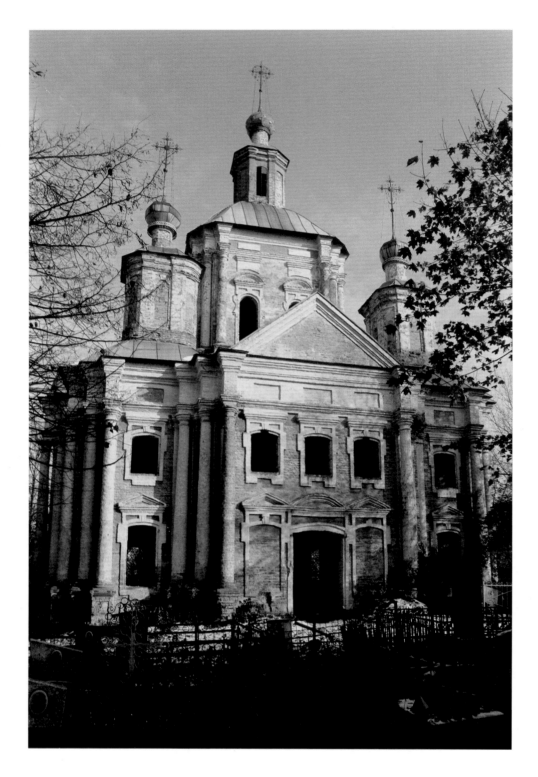

Figure 16. Viazma. Church of St. Catherine, west facade, 1791.

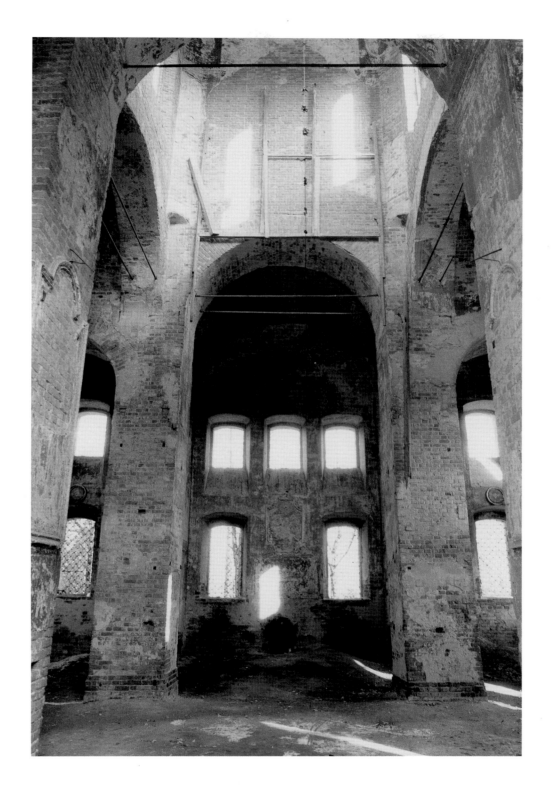

Figure 17. Viazma. Church of St. Catherine, interior.

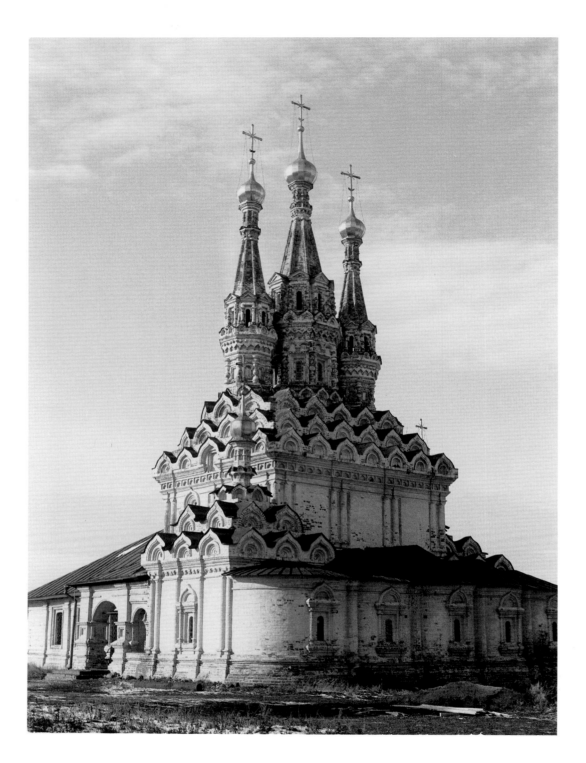

Figure 18. Viazma. Monastery of John the Baptist. Hodigitria Church, southeast view, 1635–1638.

❧

of the Ascension (late seventeenth century), and a lean, energetic abbot who supervised a few construction workers. The abbot is a man of few words, and among the locals he has a reputation as a stern taskmaster.

There are other remnants of imposing churches in Viazma, reminders of a time when the town was an important trading center. The soil here is not rich, and agriculture rarely rose above a subsistence level in Smolensk Province, although it became a major producer of flax for linen in the nineteenth century. Yet the proximity to the main route to Moscow endowed the area with a number of large gentry estates, some of which have survived and are being restored. In the midst of general rural poverty, this seems to be one of the few perspectives for development. Most of the estates, however, have long vanished, either from the war or from earlier, prolonged neglect. Some have been partially restored for institutional use, such as the former Sheremetev estate at Vysokoe, whose major buildings are on the verge of destruction (figure 19), but whose many service buildings are shared by a kolkhoz and what appears to be an aviation cadet school.

Indeed, Viazma itself is a poor town, foully polluted on its outskirts and shabby despite its scattering of impressive monuments. Little was available in the scruffy food stores apart from red caviar, odd flat, rectangular potato sheets that had the taste of chips, and the wretched Smolensk version of Russian vodka, with a furniture polish bouquet. The barren hotel, whose best suite I occupied, exemplified the age-old decrepitude of Russian provincial hostelries, without restaurant or, on this occasion, buffet. But the hotel was reasonably clean; and my sitting room contained one of the best television sets I have ever watched in Russia, with a selection that included the excellent Far East channel, not readily available in Moscow itself. (I do not own a television, but in Russia I find it a useful guide to the bewildering array of social issues loosed by *perestroika*.) Not in vain is the hill at the center of Viazma dominated by an unsightly television relay tower. For all of the petty discomforts, I was happy in this historic town that had long been inaccessible to me.

∽

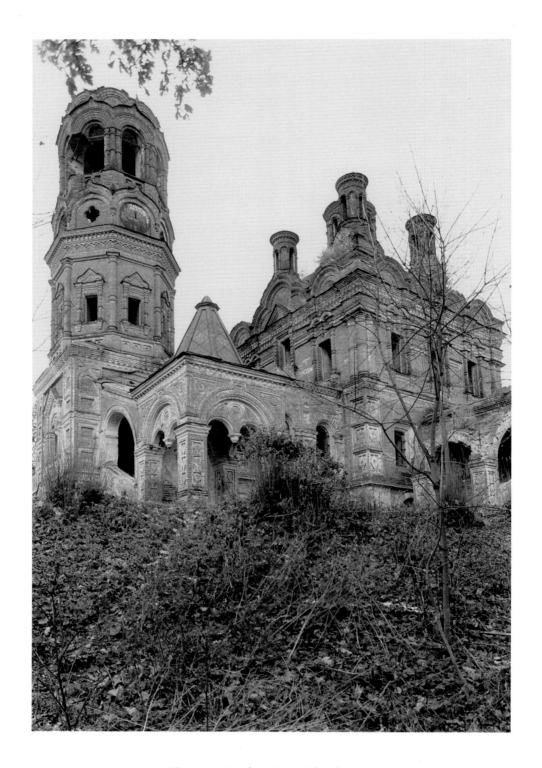

Figure 19. Vysokoe. Estate Church, 1890s.

From Viazma east to Moscow the highway passes not far from the 1812 battlefield of Borodino. One could almost imagine the flame and smoke of battle; for when the weather turns cold—as it had this year in the middle of October, the day before the Feast of the Intercession—some Russians find it useful to set fire to truck tires abandoned along the road. There seem to be a particularly large number of them on the Smolensk highway, and I was told that Russian truckers, who generally lead a hard life, use them for heat during night layovers. On another highway one rain-soaked evening, I saw a blazing tire used as a barrier light for repair work on a missing bridge span. Whatever the explanation, these burning castaways add visibly to the already numerous sources of air pollution spewn with abandon into the Russian sky from almost every small enterprise with a stove pipe.

On the approach to Moscow and three kilometers to the north of the Smolensk road lies the ancient town of Mozhaisk (112 kilometers from Moscow), founded by the beginning of the thirteenth century and frequently sacked since then. Restoration work is underway on the town's most imposing monument, the New St. Nicholas Cathedral (figure 20), begun in 1779 and completed at the time of the French invasion, in 1812. Indeed, the colorful pseudo-Gothic building, with brick walls and spire, serves in the popular imagination as a monument to the victory over Napoleon. The church was heavily damaged during the Second World War and has yet to be fully rebuilt.

The Luzhetskii Monastery, on the outskirts of town, is even more decrepit, yet the miracle is that it has survived at all. Founded in 1408, the monastery centers around the Cathedral of the Nativity of the Mother of God (figure 21), built around 1547 during the early part of the reign of Ivan the Terrible. Now stripped of adjoining galleries, the bare structure again projects the purity of form created by Russia's unknown medieval church builders. Services have been held on the grounds of the monastery, and a makeshift cross stands in the southeast corner; but there are no signs that the church will assume control of

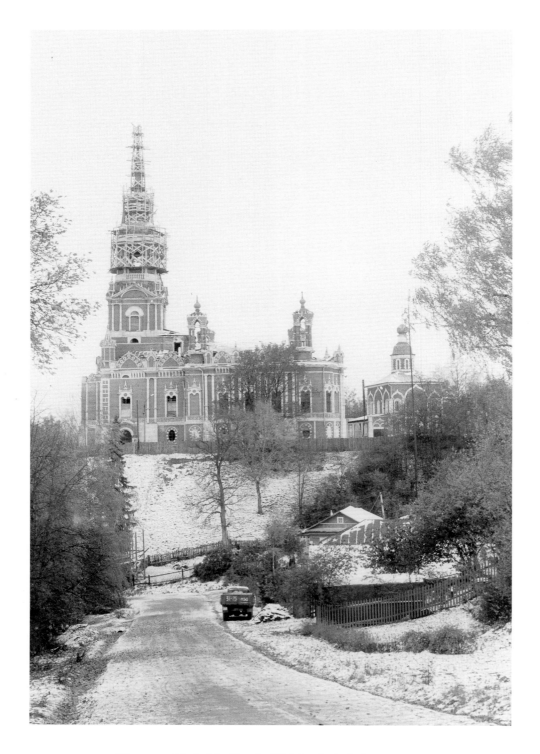

Figure 20. Mozhaisk. New St. Nicholas Cathedral, 1779–1812.

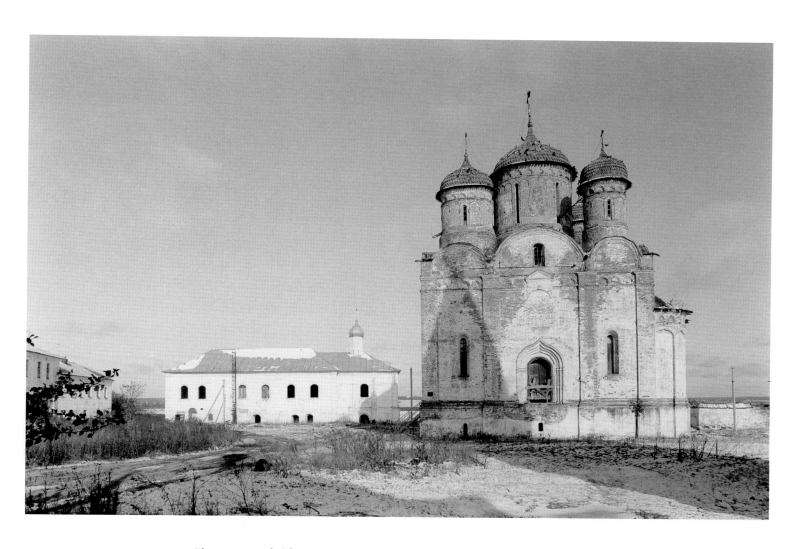

Figure 21. Mozhaisk. Luzhetskii Monastery, Cathedral of the Nativity of the Mother

of God, late 16th century.

the premises, which, like many abandoned Russian monasteries, serve as makeshift housing for a few families who have nowhere else to live.

A few kilometers to the southwest of Mozhaisk on the other side of the Moscow highway is the village of Troparevo (not to be confused with an area of the same name in the western suburbs of Moscow). I had heard that the village contained an interesting eighteenth-century church, and I was not disappointed. The Church of the Intercession, built by the owner of Troparevo in 1713, is a remarkably good example of a florid style of church architecture prevalent on the estates of wealthy Muscovite noblemen in the final decades of the seventeenth century. Although the church still soared in the fine proportions of its ascending octagons (figure 22), it was much frayed by decades of neglect. I was all the more surprised to find on the south portal an announcement of the next service in the church, now reconsecrated for use every few weeks by a visiting priest.

As we drove to the Intercession Church, Viktor suddenly revived a past of his own: the landscape reminded him that as a university student, he had spent a summer's required agricultural labor on the collective farm at Troparevo. Although born of Communist idealism and the pressing need to extract food from a crippled agricultural system, to Viktor such labor provided comraderie and a welcome relief from urban student life. As we reached the end of the road on this chilly but bright October day, Viktor caught sight of a gray-haired man in suit and coat who apparently was one of the farm's directors. After a friendly greeting and a few remarks on old times, the director went his way with a preoccupied air—as well he might: the farm had that decrepit atmosphere of so many others, and few people knew what to expect from new policies in agriculture.

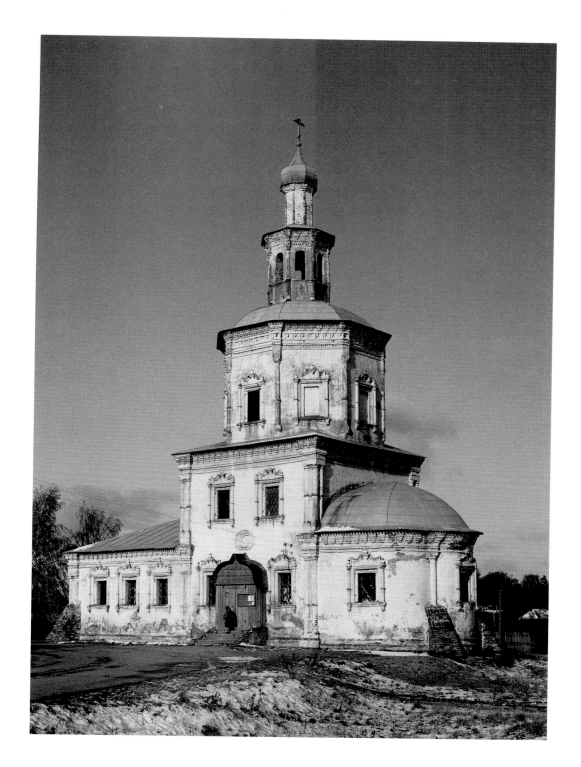

Figure 22. Troparevo. Church of the Intercession, southeast view, 1713.

∾

In a southwesterly direction from Moscow, the problems of argriculture often seem remote in forested hills that provide an idyllic setting for a number of former estates, some whose mansions have been partly preserved or were restored after the Second World War as rest homes for professional unions and the political-administrative elite. The most grandiose monuments in the area, however, now stand as ruins. At Petrovskoe-Alabino, the late eighteenth-century mansion of the Demidovs—whose fortune was based on iron works in the Urals—had been abandoned by the end of the nineteenth century. The final blow occurred in the 1930s, when it burned; yet through war and peace the walls of the structure, apparently designed by the eminent neoclassicist Matvei Kazakov, have remained in a state of grand devastation that suggests the idealized landscapes of Baroque paintings (figure 23). The nearby estate Church of the Metropolitan Peter, built in the late eighteenth century, has continued to function.

Farther to the southwest of Moscow, the road to the provincial capital of Kaluga skirts the town of Borovsk, long a center of gentry culture in the area. The nearby St. Pafnutii-Borovsk Monastery, founded in 1444 and subsequently one of the most important in central Muscovy, still has an imposing ensemble of structures dating from the sixteenth and seventeenth centuries. It is now being restored for use by the church. The town of Borovsk itself, with its air of faded prosperity, seems to have changed little in the past century.

Returning to the Kaluga highway, one is lulled by several kilometers of monotonous landscape, when suddenly there looms on the right a grandiose, towering relic that seems entirely anomolous in its impoverished mining settlement named Lev Tolstoi (in grotesque homage to the great writer). Even the bravest devotees of nineteenth-century Russian eclecticism seem to have disowned the structure (figure 24), and only after much research did I discover that it was the cathedral of the St. Tikhon Monastery, at one time among the wealthiest monasteries in Kaluga province. The pernicious effects of wealth are all too

∾

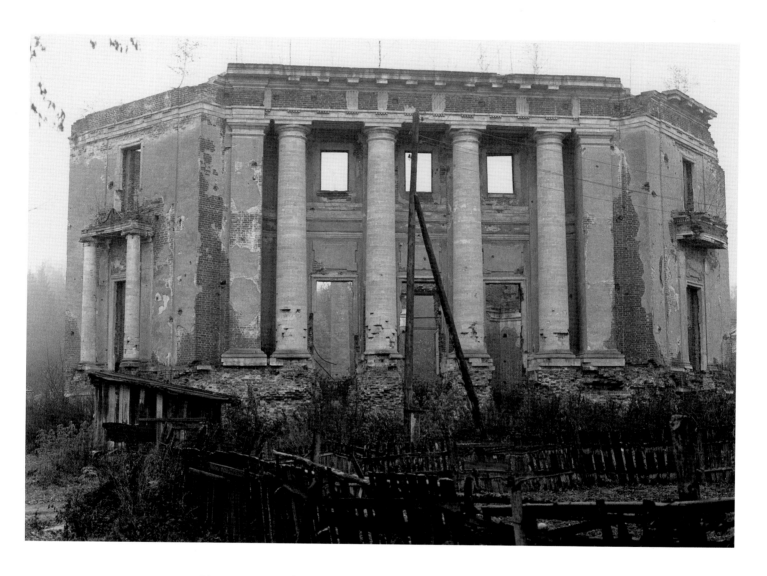

Figure 23. Petrovskoe-Alabino. Ruins of estate mansion, late 18th century.

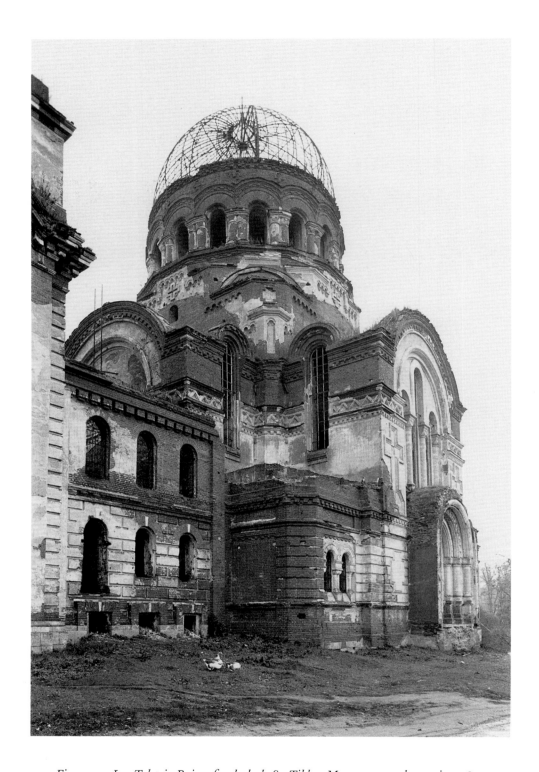

Figure 24. Lev Tolstoi. Ruins of cathedral, St. Tikhon Monastery, southwest view, 1894.

⌁

evident in the ponderous deisgn of this neo-Romanesque (!) edifice, built from 1886–1894; but in its plundered state the building reveals an impressive display of engineering, particularly in the bare, trussed, iron ribs that once supported the dome.

In order to reach Kaluga, it is necessary to turn east from the main road and onto a parkway that is landscaped and well maintained. Kaluga prospered in the early nineteenth century, and it has an array of neoclassical buildings that are among the most elegant in Russia, as well as a number of restored churches. Like other Russian cities, it suffered from inept urban planning in the 1960s and 70s; yet it now has the sheen of prosperity, due in part to its links to the Soviet (now Russian) aerospace industry. Although suffering from the economic problems that afflict the country generally, Kaluga suggests the benefits an economic recovery might bring to the Russian provinces.

The roads due south of Moscow lead through a number of cities that once served as important Muscovite outposts. Podolsk (forty-two kilometers from the capital) was incorporated as a town in 1781, and thus has no significant architecture before the nineteenth century. In the suburbs of the town, however, stands the Church of the Icon of the Sign at Dubrovitsy (1690–1704; figure 25), one of oddest manifestations of the transition between medieval church design and the imported Western tastes of the circle surrounding Peter the Great. Its massively rusticated limestone lobes and tower, with an array of statuary rare in the Russian Orthodox tradition (figure 26), are slowly being restored, as is the interior of this recently reopened church. It has become a popular site for weddings in the Podolsk area.

Serpukhov, 102 kilometers south of Moscow, still offers vistas that suggest a medieval city, although the air pollution of the late industrial revolution placed its grim mark on the city. Some of its damaged churches have been beautifully restored (figure 27). One of them provided refuge for several elderly women who told us in the bleakest terms of the

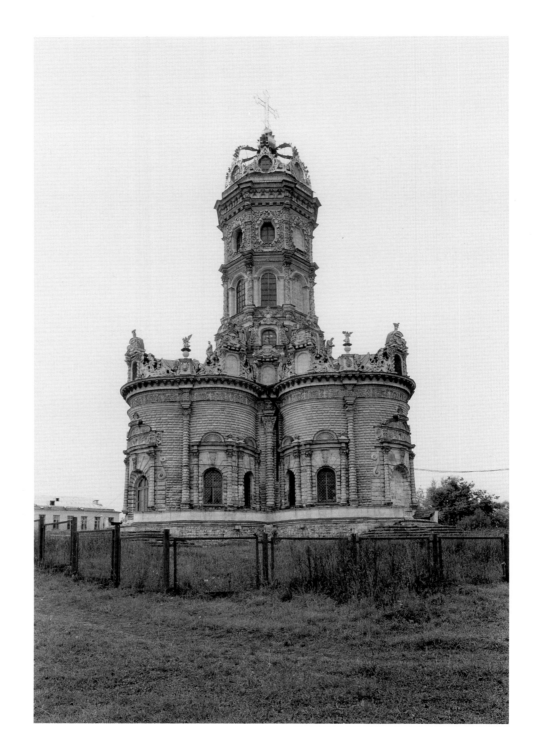

Figure 25. Church of the Icon of the Sign at Dubrovitsy, southeast view, 1690–1704.

~

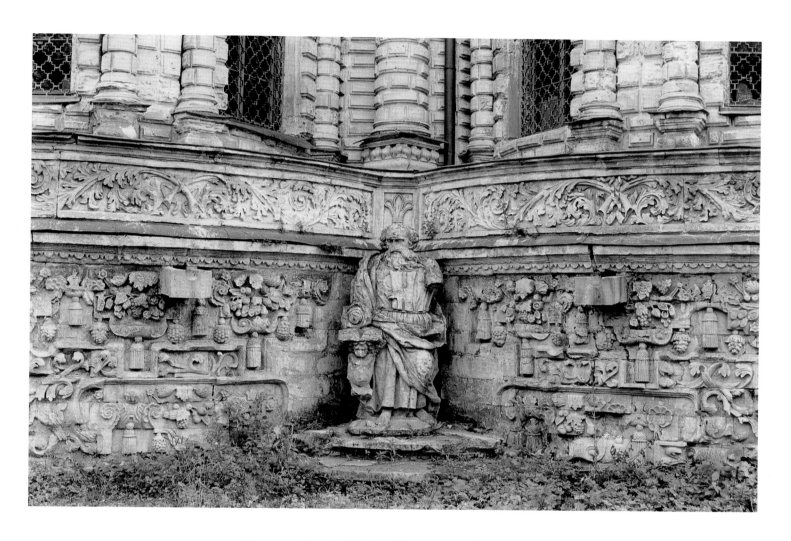

Figure 26. Church of the Icon of the Sign at Dubrovitsy, detail.

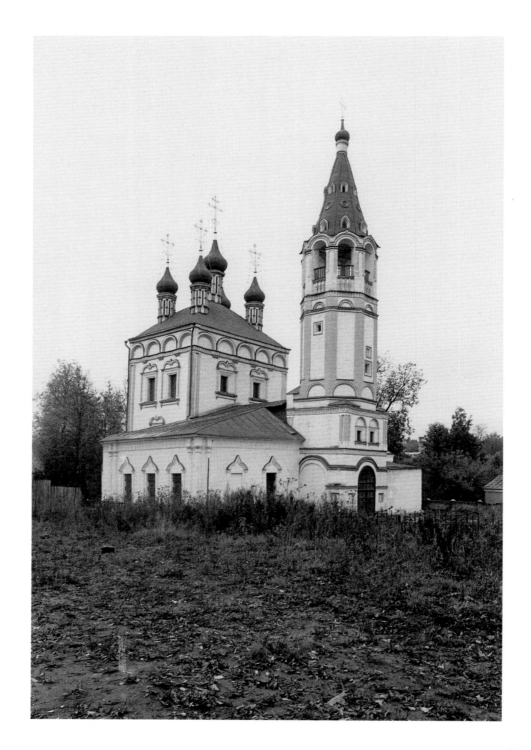

Figure 27. Serpukhov. Church of the Trinity, ca. 1700.

hardships of their existence under the new order. Almost all of Serpukhov's surviving six-teenth-century walls were dismantled in 1933 for use as building material in the first line of the Moscow subway—a symbolic as well as practical gesture, but wasteful in terms of the city's identity and possibilities for renewal.

As fate would have it, the most serious damage has afflicted the city's most valuable medieval ensemble, the Vladychii Monastery, founded in 1360 and rebuilt at the end of the sixteenth century by Boris Godunov to commemorate Serpukhov's defeat of a Crimean Tartar raid in 1598. Later additions much altered the core of the monastery; and in a maneuver typical of the late Soviet period, funds were obtained ostensibly for its restoration, which began in 1970. The attempt to uncover and restore the surviving original structures only led to their further, and perhaps irreparable, decay (figure 28).

South of Serpukhov, the broad flood plains of the Oka supported yet another en-clave of country estates. The baroque imagination of at least one landowner has survived in the remarkable rotunda Church of the Nativity of the Virgin (1754) at the estate of Podmoklovo, fifteen kilometers southwest of Serpukhov. The last kilometer is a rutted track that brushes the church itself and has recently been the source of a bitter dispute between the administration of the still-functioning collective farm and the local Orthodox believers. The church (figure 29) is currently being restored for their use, but attempts to protect the church property with a fence have been defeated by the inability to shift the road, which is nothing more than a dirt gash. The head of the small Orthodox community gave me a petition, properly stamped and signed, to take to Moscow in the hope that my ties there with promi-nent art historians might resolve the issue. I have little idea of their chances of success, and my concern is that there be no further vandalism to the structure. Anything is possible now, for better or worse.

At least at Podmoklovo there is hope for the restoration of the church. Such cannot be said of the formerly magnificent church at Rai-Semenovskoe, near the Nara River (a

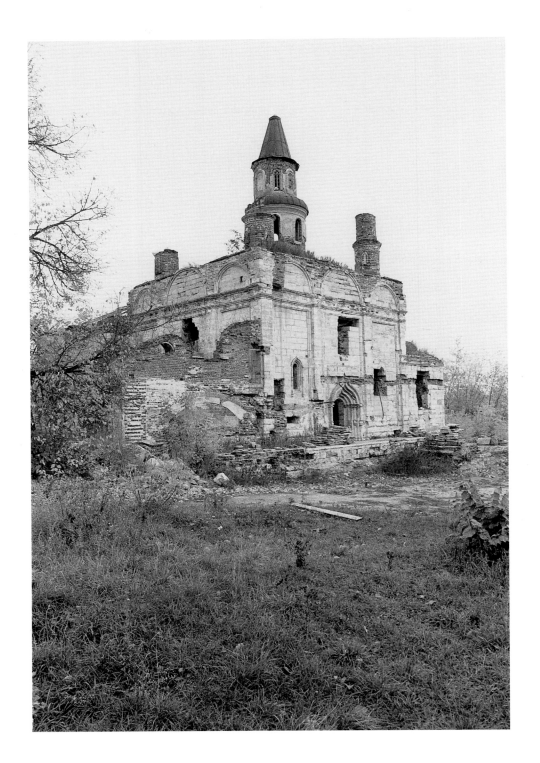

Figure 28. Serpukhov. Vladychii Monastery, Cathedral of the Presentation,

southwest view, late 16th century.

❦

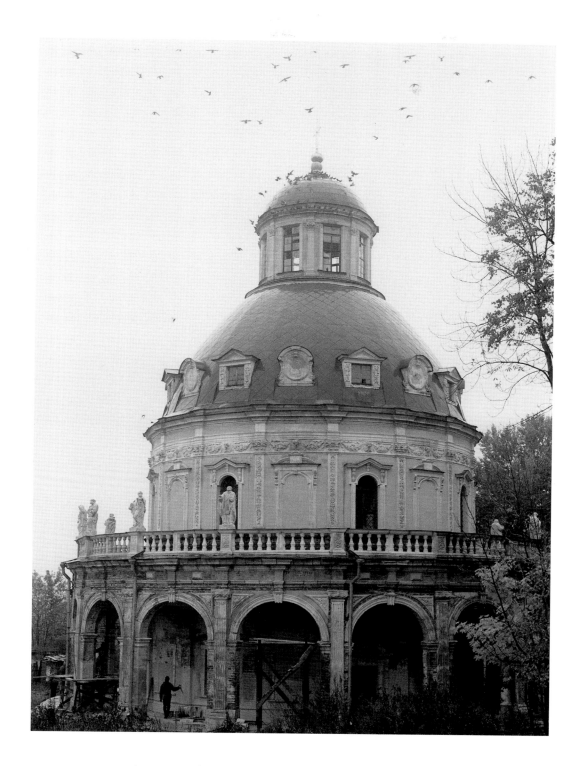

Figure 29. Podmoklovo. Church of the Nativity of the Virgin, 1754.

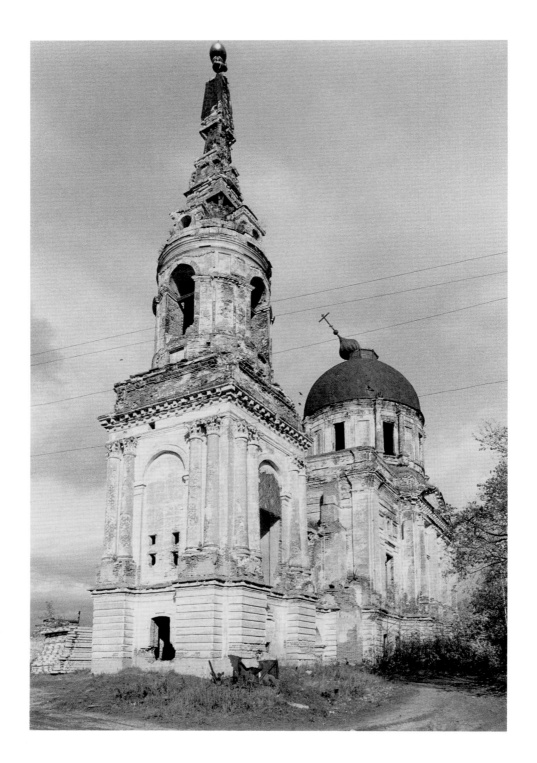

Figure 30. Rai-Semenovskoe. Church of the Savior, 1765–1783.

tributary of the Oka) a few kilometers to the north of Serpukhov. The estate was acquired in the mid-seventeenth century by the influential diplomat A. L. Ordin-Nashchokin, whose descendants retained it until the beginning of this century, when it was purchased by an industrialist. Rai-Semenovskoe is situated near mineral springs, and at the end of the eighteenth century, the Nashchokins created a small spa in the neoclassical style. Almost nothing remains of the planned resort for ailing nobles except the main house, which has been massively disfigured by its service as adminstrative center for the kolkhoz that now occupies the premises. Across a dirt road, this house is faced by several four-story standardized apartment blocks of the type that proliferated in the 1970s in an attempt to give kolkhoz families the amenities of city living.

Situated to the side of this shabby but still functioning community is the monumental Church of the Savior (figure 30), completed in 1783 to plans by Moscow's most talented neoclassical architect, Matvei Kazakov, who also designed an icon screen of Carrara marble for the sanctuary. As befitted the wealth to which Rai-Semenovskoe catered, the church interior displayed the restrained luxury of ornament and fine materials typical of high Russian neoclassicism. Virtually all of the interior work has been lost or vandalized, while the exterior of stuccoed brick with limestone details slips further into ruin.

To reach Tula, the next major administrative center south of Serpukhov, you can take the winding country road that follows the upper reaches of the Oka and leads past such preserved gems as the Church of the Trinity at Bekhovo (figure 31), which stands on a hill with, as yet, beautifully unspoiled, sweeping vistas of the Oka River valley. The church was built in 1904–1906 by the artist Vasilii Polenov with references to early medieval Russian church architecture that were typical of the Russian Arts and Crafts movement. The artist's own neighboring estate of Polenovo was one of the centers of that movement and has been preserved as a museum.

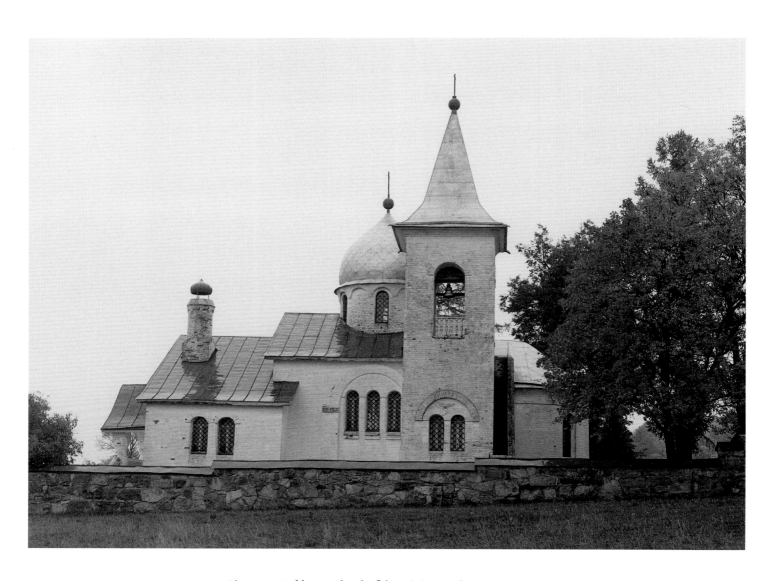

Figure 31. Bekhovo. Church of the Trinity, south view, 1904–1906.

Tula is an ancient Russian industrial city known for its armory and its fine metal work. Like other provincial Russian towns, it is being buffeted by change that will alter its appearance. There is an active movement for historic preservation in the city, although whether or not it can mobilize the resources needed for a restoration of the town's remaining nineteenth-century districts is far from certain. Here, too, the Orthodox Church is undergoing a revival, whose effects are especially noticeable at the Church of St. Sergius, built in the Russo-Byzantine style in the 1880s and severely disfigured since the 1930s by its use as a warehouse. Services now take place in a ground level chapel while the massive work of restoring the interior of the main church on the upper level is progressing slowly, as limited funds and labor permit. Even with severe damage, the surviving wall paintings—which include large scenes from the life of the fourteenth-century Muscovite patriot and founder of monasteries Sergius of Radonezh—reveal the mastery of their artists.

The grandest and most improbable of Russian ruins, the imperial estate of Tsaritsyno, is situated within the present-day city limits of Moscow. In 1775 Catherine the Great purchased from Prince Serban Kantemir the estate of Chernaia Griaz ("Black Dirt"), located in undulating terrain to the southeast of central Moscow. She intended to create a series of country residences in the area, of which the complex of palaces, pavilions, and service buildings at the renamed Tsaritsyno was to be the most extensive, rivaling the imperial estates near St. Petersburg. In this wooded setting, marked by ravines and a small river, Catherine dispensed with her neoclassical preferences in favor of the so-called Moorish-Gothic style. In fact, the architect Vasilii Bazhenov ingeniously reinterpreted old Muscovite elements cloaked by the Gothic revival but planned in the intricate geometrical arrangements of the mid-eighteenth century baroque. His materials, unstuccoed brick and limestone, are in the tradition of Muscovite architecture of the sixteenth and seventeenth centuries, as are many of the decorative motifs.

A number of the early pavilions are not extant, but the walls of the small Private (Semicircular) Palace still stand, with their exuberant limestone decoration culminating in a radiant burst around the monogram of Catherine. Like many of Bazhenov's pavilions at Tsaritsyno, the domed roof of the palace was originally covered with bright yellow ceramic tiles, associated in Catherine's mind with medieval architecture. Nearby is the no less idiosyncratic palace for state receptions, subsequently known as the Opera House (1776–1778), with the two-headed eagle outlined in limestone above the cornice and a panoply of limestone elements on the brick facade. In contrast to the stuccoed facades of St. Petersburg's palaces, Bazhenov's massive combination of brick and limestone for the imperial eagle verges on the absurd (see figure 32).

The most exquisite product of Bazhenov's imaginative fancy is also the smallest of his structures at Tsaritsyno, the Patterned, or "Figured" Gate (1776–1778; figure 32), which framed the entrance into the park with a mixture of styles intended to summon an aura of the past. The limestone lower walls of the gate, which suggest both western and Russian medieval architecture, provide a base for elaborate brick towers whose form displays in miniature certain motifs of the Kremlin walls. Within the brick and limestone arch, a pattern of suspended stone blocks reproduces the tracery of Gothic lancet windows while framing vistas of the surrounding park and pavilions.

The concluding phases of construction at Tsaritsyno revealed Bazhenov's peculiar Russo-Gothic sensibility on a larger scale. Work on the residences for the imperial family began in 1779, and by 1782 the walls had been completed for two palaces to be used by Catherine and the tsarevich Paul, as well as a third structure for Paul's children. Larger than any of these palaces was the adjacent kitchen and service wing, the *Khlebnyi dom*, begun by 1784. Designed in the form of a quadrangle with rounded corners, the building contained two stories with lancet windows on the first floor and trefoil windows on the upper story.

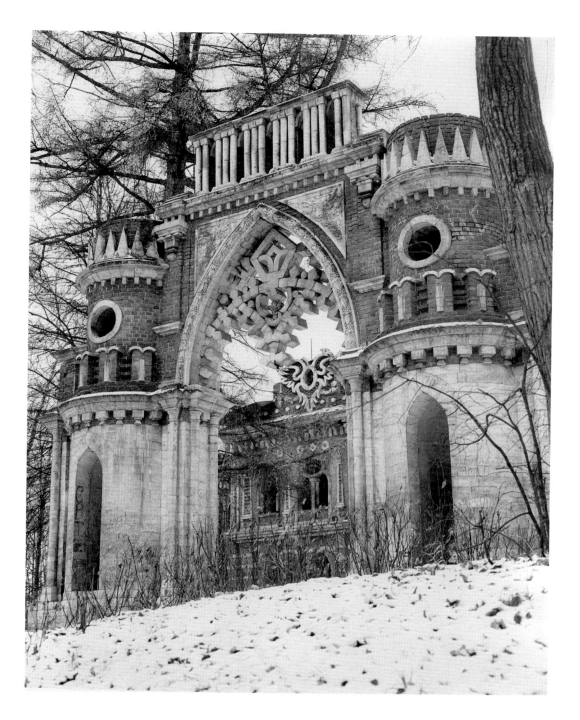

Figure 32. Tsaritsyno. Patterned Gate, 1776–1778.

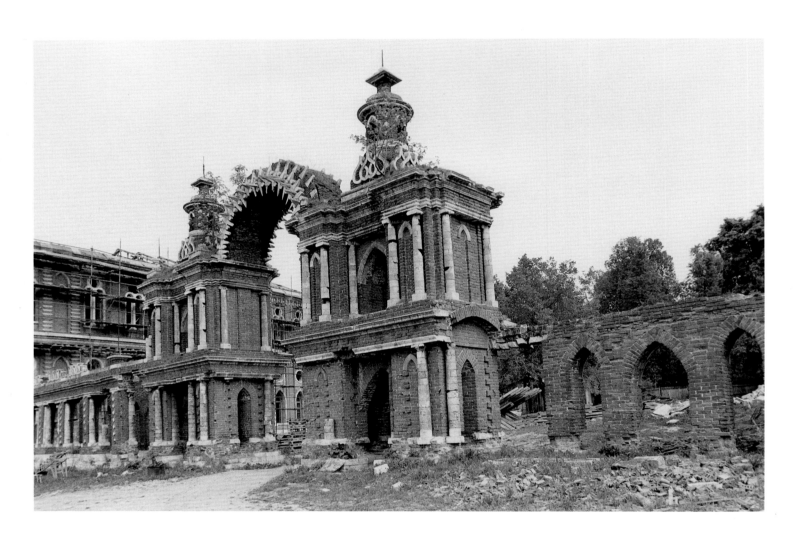

Figure 33. Tsaritsyno. Arch to service building.

Although less inventive in its limestone detail than the pavilions, the service wing was connected to the main palace compound by a colonnade and gate that comprise one of the most bizarre forms in Russian architecture. In particular the semicircular brick arch (figure 33), studded with limestone "teeth," creates a menacing air that is undercut by the coronet motif of the flanking towers.

The final flurry of construction during 1784 (in preparation for a state visit by the Empress in 1785) gave rise to other structures whose elaborate limestone figures have suggested to some the cryptic symbols of Freemasonry, to which Bazhenov belonged. The most flamboyant is the "bridge over the ravine" (figure 34) with radiant bursts of limestone emanating from the arches on either end and an array of ornament resembling folk art. But Bazhenov was the most ill-starred of Russia's great architects. Although he attempted to receive financial guarantees at the outset of work on Tsaritsyno, payments from the treasury soon waned with the reduction of patronage and a reluctance to meet previously stated commitments on the part of the imperial court. Despite these difficulties, Bazhenov had made extraordinary progress (his original plan called for the complex to be completed within three years). Yet hardly had the walls been completed for most of the structures, after ten years of work and often inadequate means, when Catherine again halted construction after her inspection visit of 1785. She commanded that the centerpiece of the ensemble, the imperial palaces, be razed, and in 1786 entrusted their rebuilding to Matvei Kazakov, Bazhenov's assistant. Catherine's decision may have been related to her growing suspicion of the possibility of an incipient opposition circle among Moscow's grandees (perhaps connected to Freemasonry); or perhaps the style and elaborate designs of the exterior facades and interior plans seemed oppressive in comparison with the stately grandeur of her suburban palaces near St. Petersburg .

Kazakov in his turn conceived a monumental, if less imaginative, palace that combined the Gothic with obvious elements of the classical order system, particularly in the

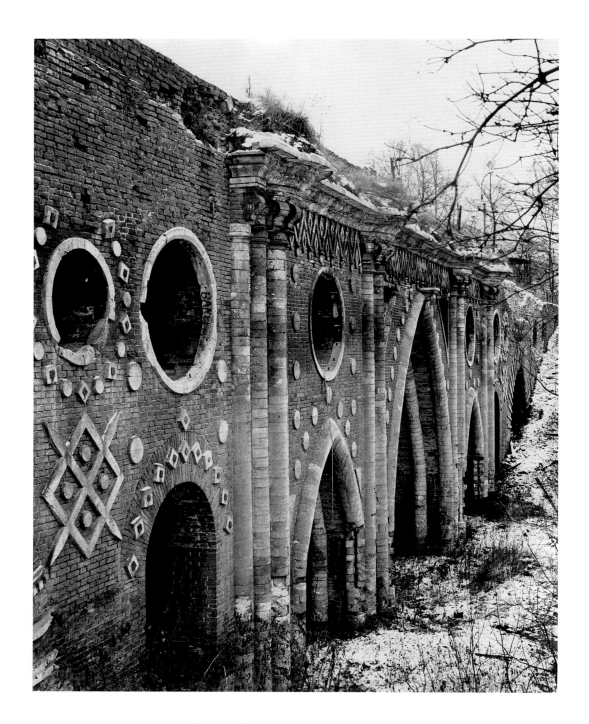

Figure 34. Tsaritsyno. Bridge over the ravine.

columns of the projecting square towers (figure 35). Kazakov already had one major pseudo-Gothic palace to his credit, the Petrovskii Transit Palace (1775–1782), used by Catherine for her visits to Moscow. Thus the new design was readily produced, and work began on the then leveled site in 1786. However, the outbreak of the Second Russo-Turkish War in 1791 again led to reduced means and futher delays. The walls of the two-story palace were covered with a temporary roof in 1793; and after Catherine's death in 1796, the project was canceled.

Whether they preferred Bazhenov's work or Kazakov's, subsequent visitors commented effusively on the grand nature of the abandoned site, which appealed so perfectly to the sentimental, romantic tastes of the early nineteenth century. There is, after all, a fine irony in the fact that this ensemble, which included among its pavilions specially designed "ruins," should itself have become so grand and picturesque a ruin. Bazhenov had intended in one massive enterprise to create an architectural fantasy doubly removed from its supposed Gothic prototypes, but related to Moscow's own past, which was a source of increasing fascination on the part of Russians who were aware of the appeal of the past in Europe and wished to find the same in their own culture.

The Tsaritsyno ensemble remained a picturesque ruin, accorded only minimal conservation during the nineteenth and much of the twentieth centuries. In the 1970s, attempts to complete some of the structures (particularly the *Khlebnyi dom*) were renewed; but the curse of Tsaritsyno lingered, as fires and shoddy work undid most of the results. In the 1980s, the painter Ilia Glazunov supported another effort, connected with his project for a Russian Academy of Art. Although the *Khlebnyi dom* was completed and is semifunctional, a larger conservation project at Tsaritsyno undertaken by a Polish firm has been delayed because of the current economic crisis. Thus, new limestone blocks contrast with the old, as construction rubble clutters the grounds. Whatever the timetable for restoration, the ruins were superbly built and should last as a monument to Catherine's folly.

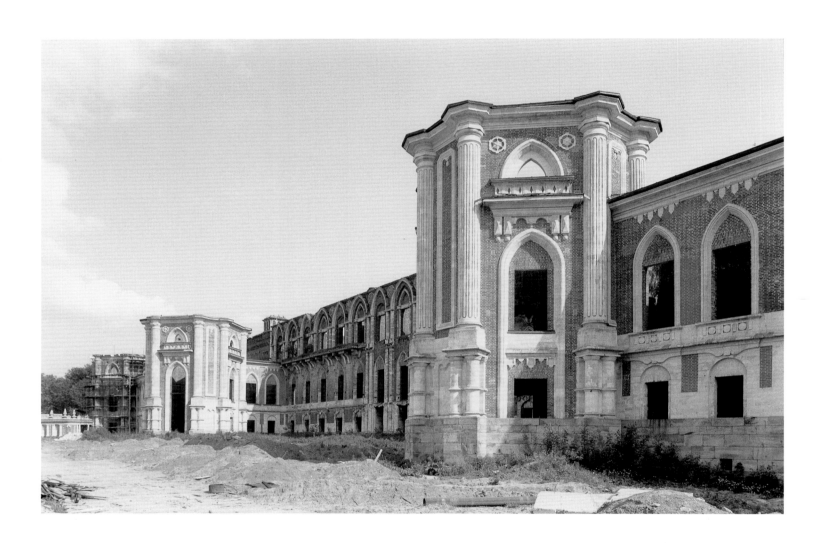

Figure 35. Tsaritsyno. Main palace, 1786–1793 (unfinished).

Farther to the southeast of Tsaritsyno and a few kilometers beyond the Moscow ring expressway stands the regal Church of the Transfiguration at Ostrov. Located on one of the Moscow River retreats that belonged to the rulers of medieval Muscovy, the church was perhaps begun by Ivan the Terrible in the latter half of the sixteenth century. Almost no documentation exists on its early history, but its striking form (figure 36) suggests similarities to votive tower churches of the period, such as St. Basil's on Red Square. In the 1830s a pseudo-Gothic brick bell tower was added on the west front, and the interior wall paintings were redone in the 1880s.

The Ostrov church now rises at the end of a rutted country path in the midst of cottages, with tethered cows, that appear to be in deepest provincial Russia, yet are in view of some of southeast Moscow's largest housing projects. While walking around the church I met a man leaning against an expensive European car who identified himself as a "sponsor," or benefactor, of the church. His front teeth were of gold, and he looked as though he had risen directly through the school of hard knocks. Yet this rough-hewn entrepreneur spoke with pride about his donation of fifty thousand rubles (the equivalent of a few hundred U. S. dollars) to the casting of six new bells for the church. When asked about the reason for his interest, he pointed to one of the distant apartment towers, across the Moscow River, and said that every morning he took pleasure in seeing the church from his window.

Inside, a service was in progress this late, golden Sunday afternoon, and a small congregation filled the soaring medieval tower with song and chant. Although the walls of this recently opened church were almost entirely bare, gaily colored children's paintings of the new church were displayed in the west gallery. Despite the often bitter arguments between the Orthodox community and museum workers, there are many examples of the joyous and reverent return of church buildings to active use, and this is one of them.

A few kilometers farther east, on the other side of the Moscow River, the Church of the Vladimir Icon of the Mother of God at Bykovo (1780s, with modifications in the early

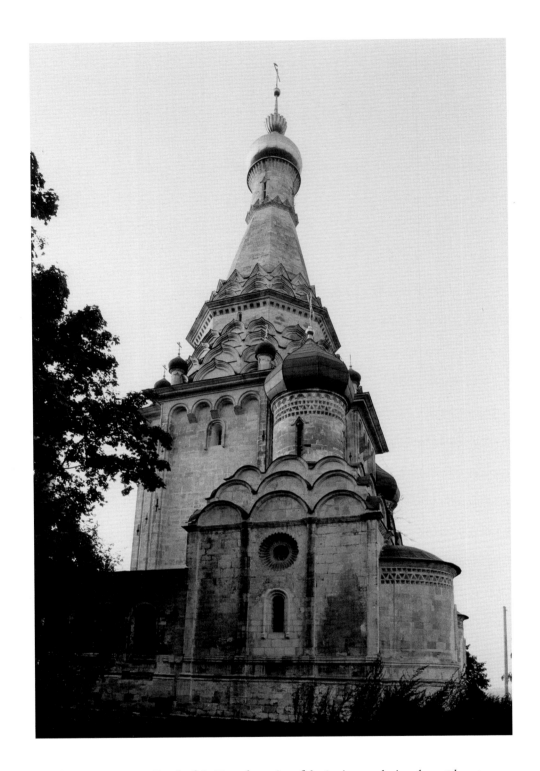

Figure 36. Ostrov. Church of the Transfiguration of the Savior, south view, late 16th century.

❧

nineteenth century) has also been returned to active use. Yet the small congregation can maintain only a chapel in the lower level of this pseudo-Gothic architectural fantasy (figure 37) that seems absurdly out of scale with the poverty of the surrounding semirural community near Bykovo Airport. There is no firm information on the architect of the building (possibly Vasilii Bazhenov), whose stone facades and long interior, flooded with light from large windows, reflect the mania for English fashion that swept much of the Russian nobility during the reign of Catherine the Great. The church is now guarded by elderly *babushki* whose appearance and manner seem the very soul of Russianness.

The countryside farther to the southeast, some one hundred kilometers from Moscow, contains a number of ruined churches whose size gives an indication of the wealth that was once produced by these lands. The ravages of neglect are most evident at the late sixteenth-century Church of the Resurrection at Gorodnia (figure 38), one of the old villages of the Sheremetev grandees. As with the church at Ostrov, the high, tent tower reminds of the great votive churches such as St. Basil's, but in this instance the additional chapels flanking the structure were created at the end of the seventeenth century.

This monument is very much off the beaten track. The view of it from the main road is blocked by a large, walled compound of urban apartment blocks of no architectural distinction, but important, nonetheless, because they provide a branch of the Russian armed forces with family housing—a prosaic detail critical to defusing of social tensions as the former Soviet armed forces scale back. We asked at the gate for directions to the church, but found it only after trial and error and much skill on the part of Viktor, who carefully negotiated the execrable field road to the site. The walls of this once-remarkable church remain intact, but even during recent decades, the walls have been further plundered for building material. Surprisingly, another local entrepreneur, who recently completed a large house of unusual design for himself nearby, proclaimed his intention to restore the church. Just how

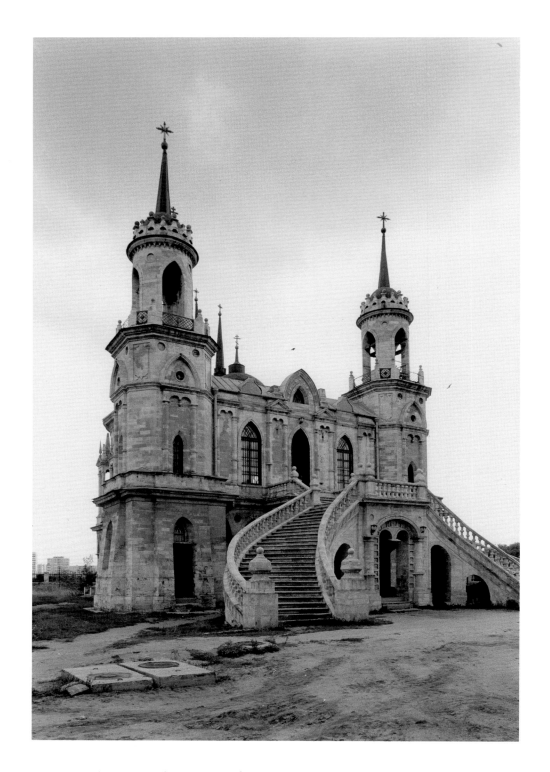

Figure 37. Bykovo. Church of the Vladimir Icon of the Mother of God, 1789.

Figure 38. Gorodnia. Church of the Resurrection, 1570s (belltower added in the 19th century).

he would go about this noble ambition without further ruining the church is unclear. Perhaps he can gain the support and guidance of preservation experts; but perhaps at this point no one cares.

A similar tale, couched in a different style, can be told of the grandiose Church of the Holy Spirit at Shkin (1794–1800; figure 39). The church has been attributed to Rodion Kazakov (no relation to the other major Moscow neoclassicist, Matvei Kazakov); yet there is no firm evidence that he was the builder, and the design bears a strong resemblance to the work of Ivan Starov in St. Petersburg. Only in Russia could there be so little information on a structure so large and so obviously derived from literate sources. Too large for reconversion to active use as a church, the structure stands in bleak isolation, polluted by a nearby settlement with the singularly graceless name of Industry. Clumps of dispirited locals gathered around a small shabby store at the end of the muddy road running past the church. One of the more unkempt asked us to take him to Industry, and for a moment I had the hallucinatory impression that he was using the word abstractly. We were unable to oblige.

But for all the desolation, the church at Shkin remains oddly impressive, its open walls now suggesting more than ever the ambiance of a classical temple. As I approached the south portico, clouds of pigeons rose to circle the dome, but they soon resettled. The stone floors of the interior were covered with a spongy carpet of droppings, but the rotunda still rose majestically, with traces of its wall paintings. It could be debated whether the area around Shkin ever needed a church of this scale, but the remnants even now bear witness to the art of building in Russia at the end of the eighteenth century.

In this area southeast of the metropolis the main highway leads to Riazan by way of Kolomna (115 kilometers from Moscow), which rivals Kaluga, Riazan, and Kostroma in containing one of the best provincial architectural ensembles. Getting to Kolomna proved to be

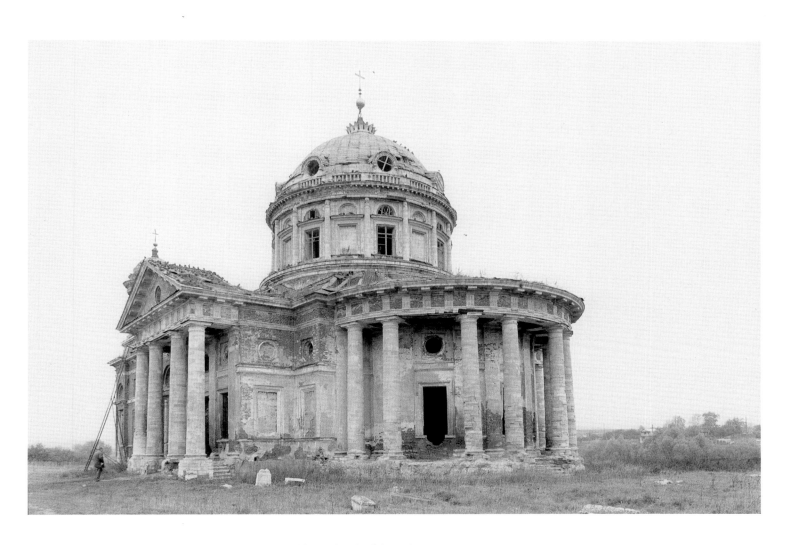

Figure 39. Shkin. Church of the Holy Spirit, east view, 1794–1800.

an adventure, not because of the highway—in reasonably good condition—but because of the pervasive problem of theft, which increasingly threatens the hard-earned gains of many Russians. Viktor was no exception. The night before my trip to Kolomna, his car was broken into and almost stolen, but for an antitheft device. Much of the damage to the car's electrical system was quickly repaired on that dreary, rain-soaked morning, but the motor for the wiper blades refused to respond.

When we set out, at midmorning, it would be misleading to say that it was raining: more like suspended moisture mixed with the dirt and fumes of Russian streets. Driving through Moscow, Viktor stopped every so often to clean the spattered windshield. But once beyond the city limits, with its boundary highway patrol station, we took up rags, and in violation of all rules and common sense, reached through our respective side windows to wipe furiously at the accumulating layers of foulness. Occasionally Viktor stopped in order to do a more thorough job of it; but every time a large truck passed us, our work was immediately undone, so that we seemed only to be shifting the dirt around with the by now filthy rags.

Yet Viktor kept on driving, with my demented encouragement. I had for years lived in hopes of seeing Kolomna, and was determined not to miss this opportunity, whatever the risk. To drive too slowly would have been dangerous, and too fast, impossible. And so for more than two hours we proceeded at about fifty kilometers per hour, accompanied by my profuse compliments at how well Viktor saw through a tiny patch in his opaque glass. We both continually assured each other that it really was beginning to clear, to get lighter. I felt the weight of every remembered "They Drive by Night" B movie. We arrived around noon, just as the clouds began to lift.

On this particular Monday the Kolomna garages were, of course, closed; and as soon as I reached the large, modern city hall, I made my way to the office of the mayor's representative who was to accompany me, and I explained the situation. He took me to the

mayor himself, past a room of petitioners who looked as though they belonged in a nineteenth-century Russian novel, and described our plight. A quick handwritten note from the potentate was produced, and Viktor was able to proceed to a state garage that accepted private work for a fee.

I, in the meantime, had a brief and polite conversation with the mayor, who accepted one of my publications on Russian architecture and explained that the city wanted to do as much as possible to preserve what remained of its historic architecture. During our meeting, I could not help but notice (without comment) the large portrait of Lenin on the wall above the mayor. Icons of the Bolshevik leader still abound throughout the provinces. Yet on our way downstairs, we met the young *hegumen* (superior) of a reopened monastery who was clearly at home in the corridors of secular power. In contrast to caricatures of monastic authority, he was anything but overweight and had the face of a Russian intellectual. Indeed, he had done graduate study at the Institute of Art History in Moscow before taking monastic vows—ideal qualifications for one whose responsibilities include renovating a large monastery. Unfortunately, the delay in my arrival left no time to visit his institution, across the river from Kolomna.

We proceeded instead to the southern edge of town, site of the Old Golutvin Monastery, whose brick walls were rebuilt by Matvei Kazakov in the pseudo-Gothic style during the 1780s in honor of a visit by Catherine the Great to Kolomna. I had long wanted to see this architectural oddity, which revealed yet again a sad example of neglect, not helped by interminable restoration efforts without proper funds or purpose. The situation was worsened by the fact that the monastery had not been returned to the church, but was being "rehabilitated" by a sports club for their own use. Still, the Russo-Gothic towers retained much of their builder's fantasy in brick and limestone (figure 40).

Returning to the center of town, we made our way to the New Golutvin Monastery, which is not only being renovated but has also become a functioning monastery and reli-

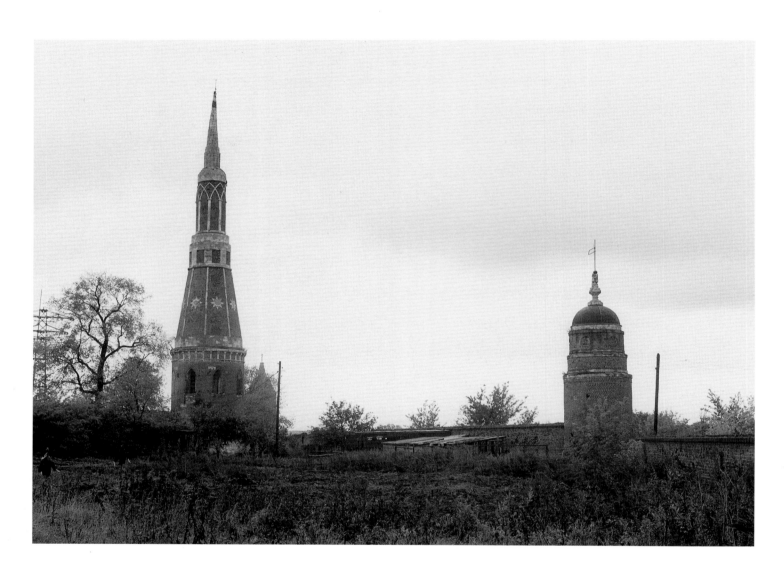

Figure 40. Kolomna. Old Golutvin Monastery, walls and towers, late 18th century.

gious school. The students live in simple but well-maintained dormitories, and a sense of discipline and respect for the relatively young monks that direct the institution was evident everywhere—from the students to the construction workers. A squall with mixed snow and hail had hampered my photography on the way to the monastery, and it was with relief that I accepted the invitation to participate in the mid-afternoon meal with the two directors of the monastery school. The simple, nourishing food was prepared and presented with care, and the coversation about icons and architecture was well-informed on both sides. They had their duties, however, and I myself noticed with barely concealed urgency the appearance of the sun, whose light had the ineffable brilliance that often occurs after an autumn storm in Russia (figures 41, 42).

The two preservationists who accompanied me were both committed to the restoration of historic architecture, yet they had often sharply opposing political views. While the one affiliated with the local history museum had no doubts about the need to consign the Soviet period to history and restore the prerevolutionary names of the streets (something that has been done at various tempos in a number of Russian cities), the other, affiliated with the city administration, cautioned against excessive haste. Later in the afternoon, after the museum specialist had left, he confessed that life had been acceptable to him and his family during the period of "stagnation" (a term used to refer to the Brezhnev era). By that he meant that his education had been free, his work as a restorer had supported by the state, and his family's material needs had been met. He was suspicious of the ethical values of a market, entrepreneurial system, and bitter over what he saw as the artificially induced fall in the value of the ruble.

It would be difficult to convince him that Soviet methods of production and distribution had led the country into bankruptcy. At no point in our friendly conversation did I sense that he would condone violent or undemocratic means to return to the old order, yet his distate for the new expressed itself in a longing for the old. And there are millions like

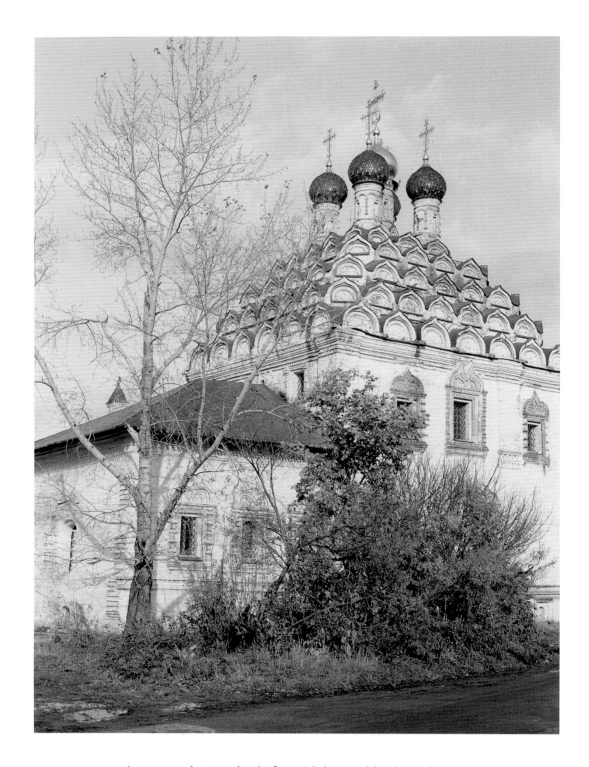

Figure 41. Kolomna. Church of St. Nicholas Posadskii, late 17th century.

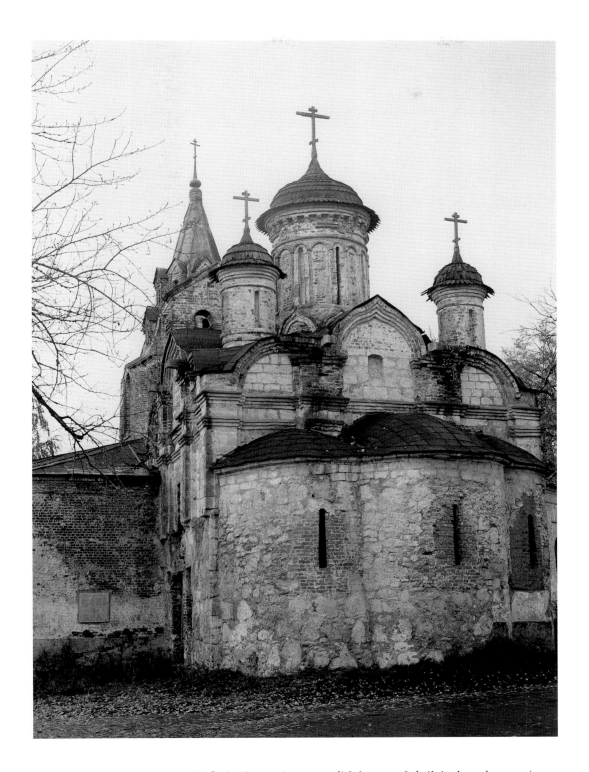

Figure 42. Kolomna. Church of John the Baptist on Gorodishche, 1370 (rebuilt in the 16th century).

87

him: entering middle age, well educated, but still suspicious and awkward in a changing political and economic era. As for himself, he held unswervingly to the belief that his work in restoring the heritage of the city's architecture was something he could bequeath to his children, something tangible that they could see and remember. Yet in Kolomna, as elsewhere, the question of material support is particularly acute and brings into doubt the intelligent plans for historic preservation that are partly underway.

On the way back to Moscow the October clouds again gathered, but there was no rain. The windshield wipers worked.

Anyone who wishes to see the full extent of the casual devastation of Russia's architectural landmarks need go no farther than Marfino, a few kilometers to the northeast of Moscow. Now a vacation and retirement community for the armed forces, the Marfino estate has had a long and distinguished history as one of the grandest in the Moscow area. Its development culminated in the late 1830s, when Mikhail Bykovskii rebuilt the main house and other structures in the pseudo-Gothic style—one of the last examples of Anglophile indulgence in architecture and landscaping (figure 43). As long as the Soviet military needed the palatial main house, it remained in habitable condition, and thus survived as a masterpiece of late romantic architecture in Russia. With the construction of new multistory housing blocks for the convalescing officers, however, the "castle" was not only abandoned but thoroughly ransacked (figure 44). Whether this damage occurred with the intention of gutting the structure for renovation is unclear; but it is clear that such a renovation cannot be undertaken without a massive infusion of private funds. Another picturesque ruin and a senseless loss to Russia's cultural and architectural heritage.

Yet there are buildings that defy ruin. In my exploration of the area around Moscow, no single monument required more effort, or was more richly rewarding, than the

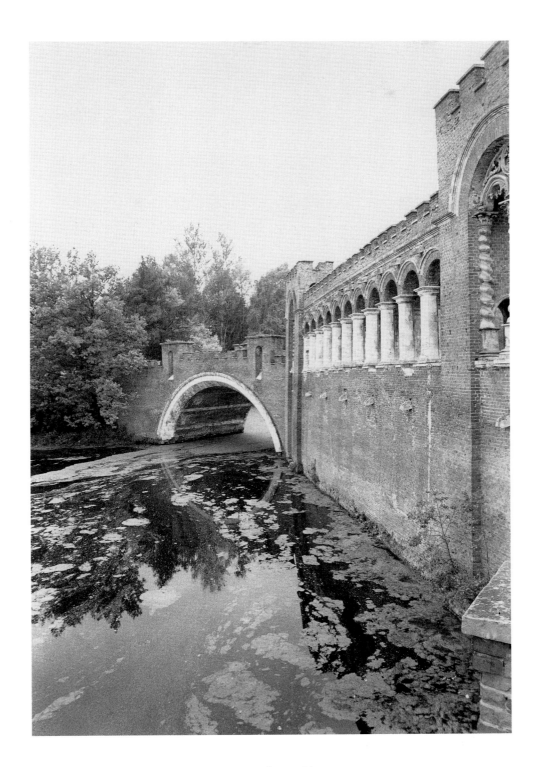

Figure 43. Marfino. Bridge, 1830s.

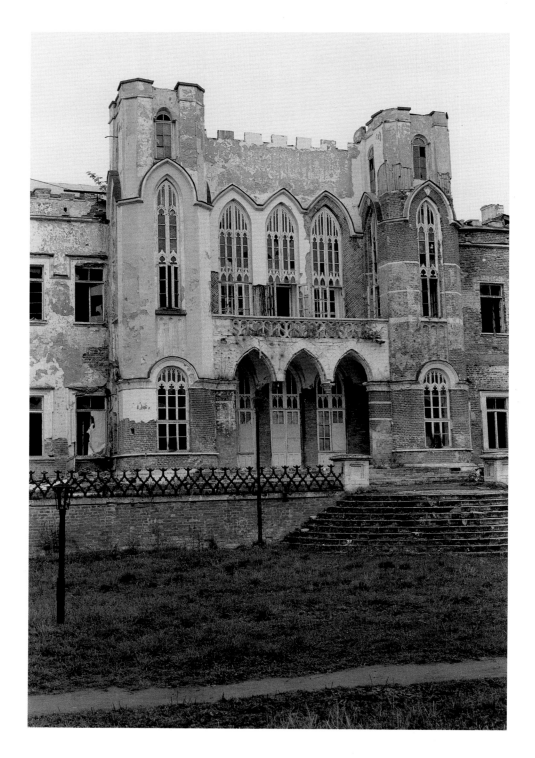

Figure 44. Marfino. Ruins of palace, 1830s.

Church of the Annunciation at Taininskoe, a few kilometers northeast of Moscow. In early May 1980, I went there with a colleague from the Institute of Art History, who had urged me to see it. (At that time anything beyond the Moscow Ring Highway was still technically off limits without a visa.) A suburban train left us at a platform with no bus service. We finally shouldered my camera equipment and walked the distance, three kilometers, on a dusty road through a rural landscape that had just begun to show spring colors.

The church was in the middle of a field (figure 45), on high ground and surrounded by a concrete fence maintained by one of the collective farms that surround Moscow. The farm had apparently adapted the church for use as a carpentry workshop. After much negotiation with the woman from a nearby house who guarded the deserted site, we got through the gate and walked around this pilgrimage church built in 1677 by Tsar Aleksei Mikhailovich. The interior was closed and not in good condition; it had been neglected even before the revolution. But from a distance and flanked by trees with early foliage, the white form of the church seemed miraculously intact. Behind it, an approaching thunderstorm gave the sky the color of lead, while the church shone brilliantly in the sunlight. Such a dramatic confluence of setting and atmosphere occurs infrequently; yet there are moments when time seems to halt in the Russian countryside, or in a secluded corner of Moscow itself.

Despite decades of neglect, the central Russian provinces grouped around Moscow are still rich in monuments of historic architecture. To the east are Vladimir and Suzdal, with their colorful, if depleted, array of churches and monasteries. Indeed, the city of Vladimir hardly qualifies as "lost Russia": its twelfth-century limestone monuments, such as the Dormition Cathedral, are among the best known in Russia and are complemented by several excellent seventeenth- and eighteenth-century brick churches.

In the countryside to the east of Vladimir, however, there stands in splendid isolation—and for decades close to ruin—what is arguably the most perfect thing in medieval

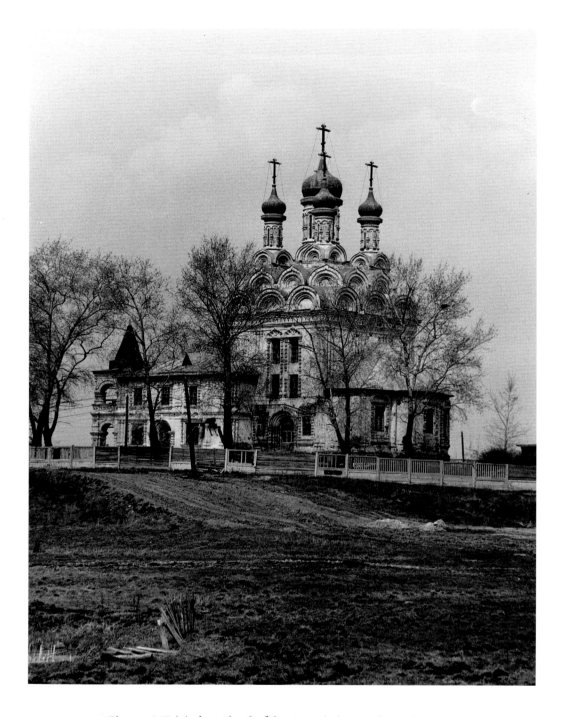

Figure 45. Taininskoe. Church of the Annunciation, southeast view, 1677.

❧

Russian architecture: the Church of the Intercession on the River Nerl. Commissioned in 1165 by the hot-tempered Andrei Bogoliubskii, who had his palace nearby, the church was built by unknown masters to commemorate one of Andrei's victories over the Volga Bulgars. (He was always fighting someone, including neighboring Russian princes: and it was he who shifted de facto political power in Rus from Kiev to his own domains in the 1160s.)

The church is unusual in several respects, including its finely calculated proportions of ashlar limestone, and its precedence as one of the first Russian churches dedicated to a Byzantine miracle that Andrei elevated to a major feast day: the Intercession of the Mother of God, or, in Russian, *Pokrov*, referring to the protection of the miraculous veil of Mary. As an appropriate setting for this jewel, Andrei ordered the building of an artificial hill at a bend in the Nerl, formerly a navigable tributary of the Kliazma River but now a quiet oxbow lake. Soviet authorities desecrated this poetic landscape by erecting, some one hundred meters from the church, a row of large pylons carrying power lines eastward. Such is progress.

I had first photographed this site on a bright winter day early in 1972, with no thought of writing histories of Russian architecture. Little did I know that those few, clear slides would have to serve as my basic photographic resource during the next two decades. Needing more photographs of the church for my first book on Russian architecture, I joined a group of American students at the Pushkin Institute in Moscow on an excursion to Vladimir in October 1979. As the resident director of another American study program at the same institute, I thought that no one would notice.

I was wrong, and the trip was an excercise in frustration. Not only did the day show the worst of a Russian autumn—foggy, polluted, heavily overcast—but after leaving the group with the Vladimir guide, taking a suburban train to Bogoliubovo and traversing over a kilometer of slippery sheep pasture leading to the church, I found that much of it was covered in scaffolding. Only a few detail shots were open to me. Turning to leave, I noticed

a couple of amiable companions—apparently a local police operative and his student assistant—busily taking photographs of me. I later heard various reasons for the authorities' concern over an unescorted American in that area: an unsightly potato harvest (indeed), some sort of local asylum, or just the general suspicion of foreigners with cameras.

Whenever I returned to the area during the following years, the Intercession Church was still under restoration or inaccessible because of seasonal flooding. In March 1994 I took a group of American students to Vladimir, and the thought of going to Bogoliubovo never entered my mind—even with the day's brilliant sun. When we arrived, I heard the local guide board the bus and say that our first objective was not to visit the usual Vladimir cathedrals but to visit the Intercession Church. Dumbfounded by this turn of events, I impatiently followed the ten kilometers of road to Bogoliubovo, let the group proceed with the guide at a slower pace, and ran to the brilliant snow-covered field leading to the prize: *Pokrov na Nerli*. Only because of this year's unusually heavy snowfall did I still have solid footing on what would soon become an expanse of slush.

The church had been beautifully restored, particularly its roofline and cross (figures 46, 47). A monk from the nearby monastery now lived in a cottage behind the church, and he opened the doors to the church. By the time the group arrived, we were able to go into this soaring, graceful space that I had never seen in person (figure 48). Cats are frequent guardians of Russian churches, and there were two here, including one playfully pulling at a rug on the bema before the altar. In the apse itself there stood one icon, of the Miraculous Veil of the Mother of God. The exquisite wisdom of placing one image in an interior once covered with frescoes and icons gave a surge of hope for Russia's cultural and spiritual revival.

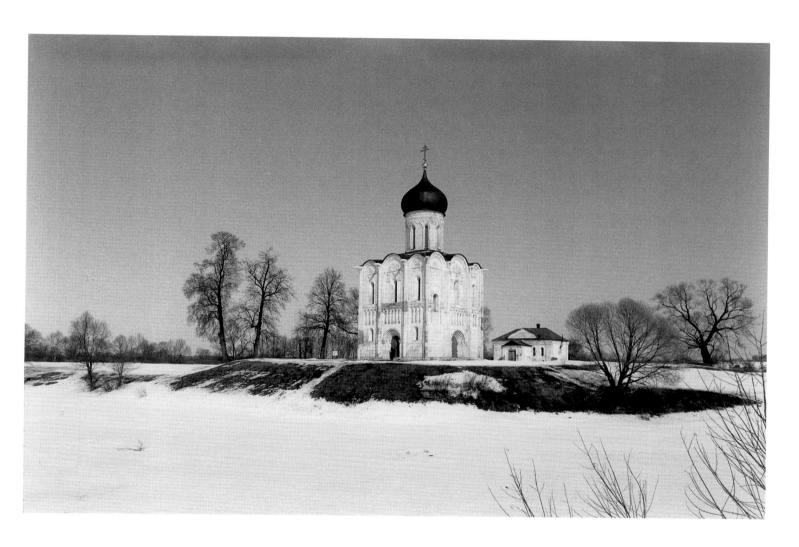

Figure 46. Bogoliubovo. Church of the Intercession on the Nerl, west view, 1165–1166.

~

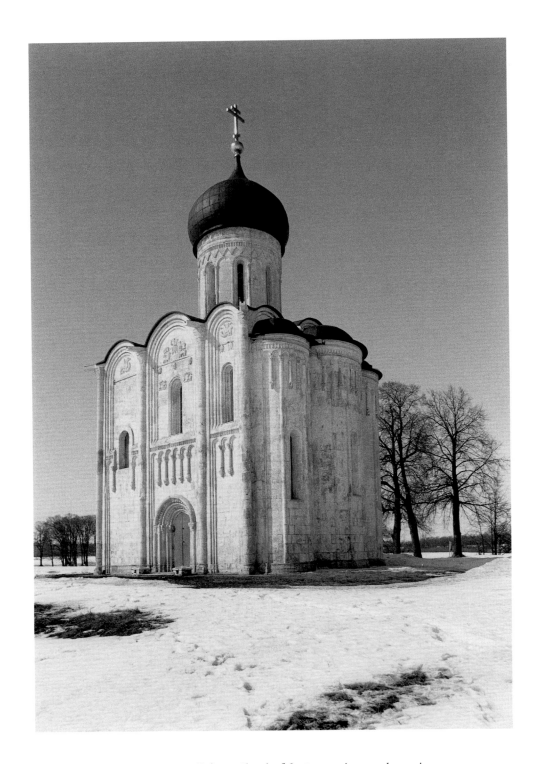

Figure 47. Bogoliubovo. Church of the Intercession, southeast view.

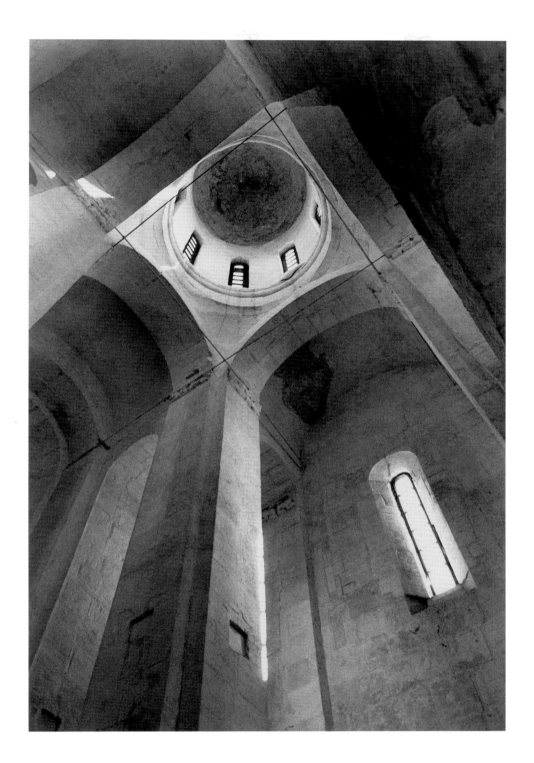

Figure 48. Bogoliubovo. Church of the Intercession, interior.

∾

The richest path for pilgrims, pioneers, and lovers of ancient architecture lies to the northeast of Moscow, along the road to Yaroslavl on the Volga River. The route passes by Sergiev Posad, location of the renowned Holy Trinity-St. Sergius Monastery; the medieval town of Pereslavl-Zalesskii, some of whose monuments are recently restored, although others continue in appalling decline; and Rostov Velikii (the Great).

Rostov is a fortunate example of a provincial city whose monuments have in many cases been the object of extensive and prolonged restoration efforts. This does not exclude cases of serious neglect, some of which are now being repaired by the Orthodox Church, particularly at the Savior-Yakovlev Monastery (figure 49). Nearby are the haunting ruins of the Church of the Savior on the Sands, first built in 1603 and enlarged at the end of the seventeenth century (figure 50). It is the only remaining part of the Savior (Spasskii) Monastery, founded in the thirteenth century and merged in 1764, on order of Catherine the Great, with the adjacent Yakovlev Monastery. At the time of my visit (October 1992) there were no specific plans for the repair of the church, which stands in grand isolation among the monastery ponds and gardens.

The most remarkable ensemble in Rostov is the Court of Metropolitan Jonah, an energetic church leader who in the late seventeenth century made use of the vast resources at his disposal to erect within twenty years—between 1670 and 1690—not only several large churches and buildings for the metropolitan's court and residence (also known as the Rostov Kremlin), but a magnificent set of walls with towers and gate churches, situated on the north shore of Lake Nero. During the latter part of the nineteenth century, the study and restoration of the Rostov Kremlin churches, with their remarkable frescoes, were implemented with a thoroughness unusual for that period. Spared the worst excesses of war and revolution, the ensemble was severely damaged in 1953 by a great storm, after which a new phase of renovation lasted until 1960. Additional work continues to this day.

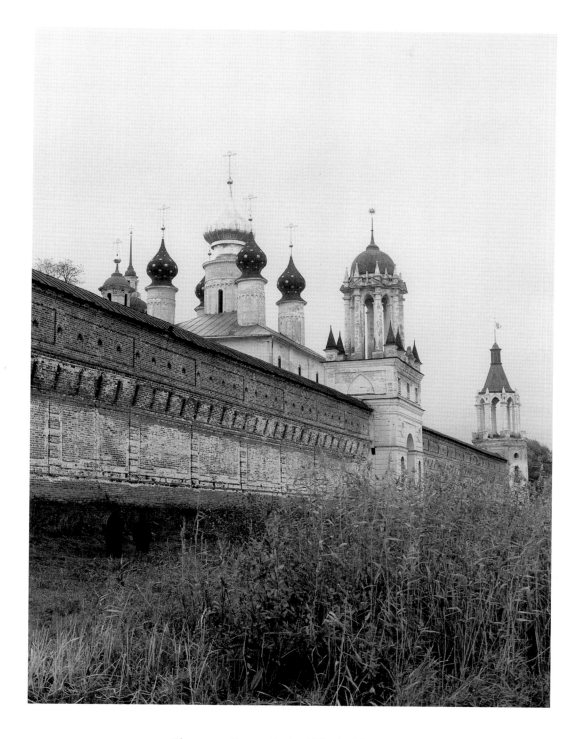

Figure 49. Rostov. Savior-Yakovlev Monastery.

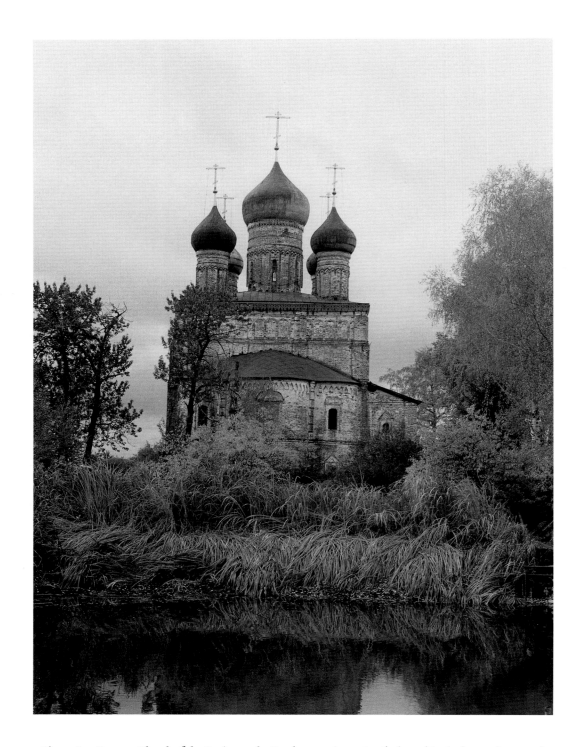

Figure 50. Rostov. Church of the Savior on the Sands, east view, 1603 (enlarged in the late 17th century).

Within the walls, the main part of the compound is occupied by buildings associated with the functioning of the metropolitanate, such as the Red Chambers or palace, used as the metropolitan's residence, and the magnificent churches. The west wall of the Rostov Kremlin centers on a gate church, built in 1683 and dedicated to St. John the Divine (figure 51). Although similar in design to the Gate Church of the Resurrection, on the north wall, St. John is more elaborately decorated, with a frieze of ogival arches on the upper walls that imparts a Gothic appearance. Taken together, these and other buildings of the ensemble compose a vision of the heavenly city, the ordered world of Russian Orthodoxy at the moment before its transformation by Peter the Great.

A similar, if lesser, vision is manifest in the Monastery of Saints Boris and Gleb, in the small town of Borisoglebsk, some thirty kilometers northwest of Rostov. The cathedral and adjacent churches of this monastery-fortress date from the 1520s, but Metropolitan Jonah initiated a new phase of construction in the latter part of the seventeenth century, at which time the ensemble began to resemble the Rostov Kremlin, particularly with the construction of large gate churches (figure 52). The most recent intensive period of restoration occurred here in the 1960s, as a result of which the monastery's status as a museum was reaffirmed. At the present, however, the main cathedral has been returned to use for worship, and restoration work has begun on its icons and wall paintings, most of which were done in 1911, but in the medieval style. Work on the cathedral interior, with its radiant frescoes, goes slowly: the number of worshippers here is small and funds are more difficult than ever to obtain.

The roads north of Rostov lead through a forested northern landscape opened by large fields. In the midst of small villages, there are, surprisingly, a few churches that have remained active and in good condition, including the remarkable rotunda church of St. Sergius at Tatishchev Pogost. Built in 1810 by an unknown architect (to an Italian plan, according to local lore), the neoclassical design with interior colonnade is an extraordinary achievement.

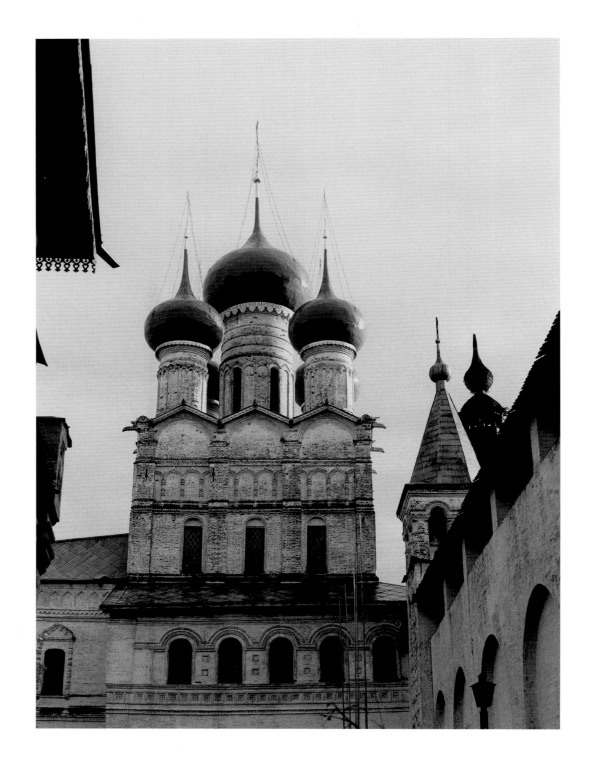

Figure 51. Rostov Kremlin. Gate Church of St. John the Divine, 1683.

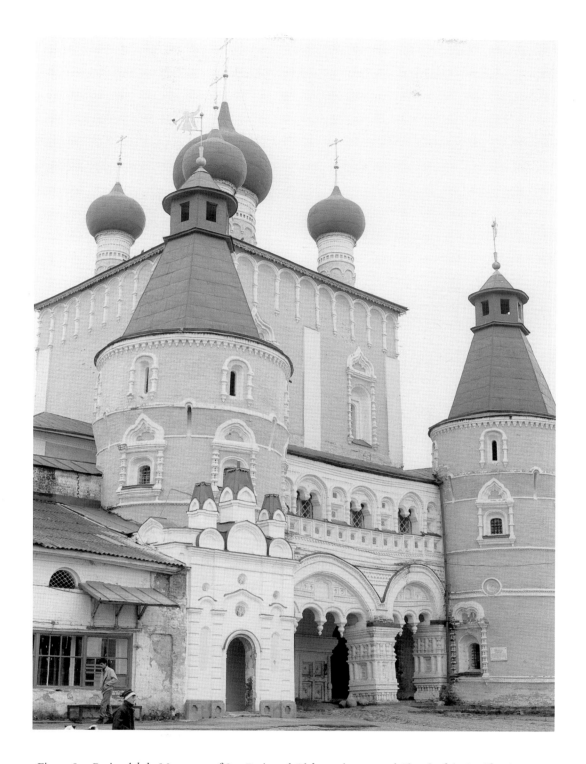

Figure 52. Borisoglebsk. Monastery of Sts. Boris and Gleb, north gates and Church of the Purification, 1680.

The culminating point of this northern journey is the city of Yaroslavl on the Volga River. Historic preservation, particularly of the city's remarkable seventeenth-century churches and frescoes, has long been an issue here; but in an era of uncertain reform, the situation has become more complex with the demand of various church groups, including Orthodox and Old Believer sects, for the restoration of church property to active use. Here, as elsewhere, some projects for renovation have been halted for lack of funds, yet the often acrimonious disputes between believers and museum workers have been resolved for some of the city's greatest monuments, such as the Church of Elijah the Prophet, located on the main square (figure 53).

The Elijah church epitomizes the relation between commerce and ornamentation in seventeenth-century Russian architecture. Since the time of Ivan the Terrible, Yaroslavl's strategic position on the trade route from the White Sea to Siberia and the East had attracted colonies of Russian and foreign merchants (English, Dutch, German), and this activity increased the resources available for the construction of elaborately decorated local churches. The donors of the Elijah church, the Skripin brothers, possessed great wealth gained from the Siberian fur trade, and they had access both to the tsar and to the patriarch of the Russian Orthodox Church. In 1647 they endowed the Yaroslavl church, with its five cupolas and an enclosed gallery. (The contoured roofline was simplified in the eighteenth century.) The exterior of the structure is brightly decorated, a typical feature of churches endowed by wealthy merchants in the seventeenth century.

Like many churches of its period the Elijah church had chapels flanking the apse on the east, of which the north chapel represents a small self-contained church with a pyramid of *kokoshniki,* or decorative gables, beneath its cupola. The balanced asymmetry of the ensemble is most apparent, however, in the two towers attached to the west of the structure: the bell tower at the northwest corner and the separate Chapel of the Deposition of the Robe, connected to the southwest corner of the church by the raised gallery. Above this

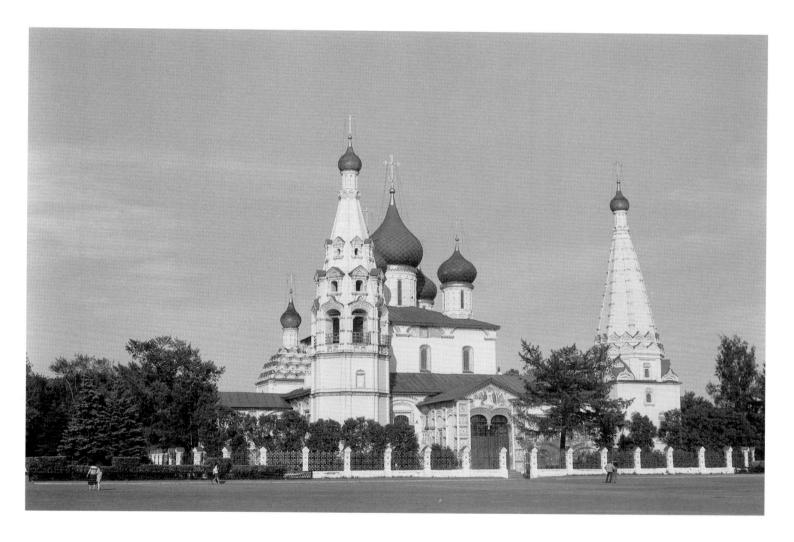

Figure 53. Yaroslavl. Church of Elijah, west view, 1647–1650.

chapel rises what is perhaps the last great, tent tower to be placed over a church. Indeed, it is not a part of the main structure, as though its presence were increasingly remote from the accepted definition of the structure of the Orthodox Church.

Thirty years after the completion of the church in 1650, the widow of one of the Skripin brothers commissioned the painting of the interior of the main church by two of the most accomplished fresco artists in seventeenth-century Russia, Gurii Nikitin and Sila Savin. These frescoes, among the best-preserved in Russia, illustrate in their rich, vigorous scenes the growing secular influence in Russian religious painting during the late seventeenth century (figure 54). When the Orthodox community demanded return of the church for worship in 1990, a confrontation arose with preservationists who insisted that the frescoes had a major cultural significance that transcended the needs of a local parish. A temporary compromise allows the church to be used for worship except in the winter, when dampness, cold, and winter clothes would more likely damage the painted walls, large segments of which are under restoration.

The complexities of restoration are more evident in the Church of John the Baptist at Tolchkovo, constructed between 1671 and 1687 with funds provided largely by Rodion and Leontii Eremin, whose wealth derived from leather-working enterprises located in the district. Its basic plan is typical of the period, with an enclosed gallery flanking three sides of the rectangular structure and symmetrical chapels on either side of the east side. Entrance porches with steeply pitched roofs mark the center of the north, west, and south galleries, and the elaborate forms of the brick are complemented by polychrome tiles on the facade. Painted under the supervision of the Yaroslavl master Dmitrii Grigorev Plekhanov between 1694 and 1700, the frescoes that cover the spacious interior walls include Western architectural motifs, yet the figures themselves and the details of the biblical scenes suggest a local setting connected to the commercial prosperity of Yaroslavl.

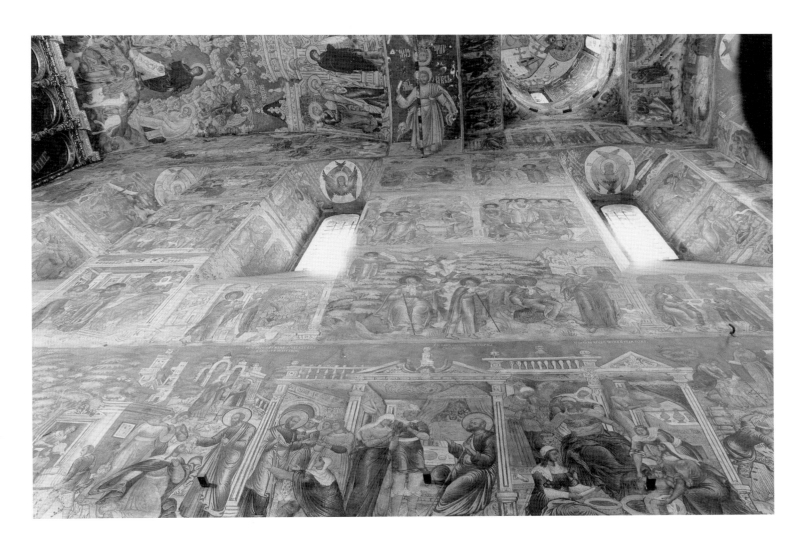

Figure 54. Yaroslavl. Church of Elijah, interior, south wall.

Neither the artists nor architects of the church could have foreseen that one day it would be surrounded by a large chemical factory, which in the 1930s painted over the frescoes and converted the building for use as a canteen and other things. Restoration efforts, begun in the mid 1980s, are still in progress, as I witnessed when admitted to the interior by a curator from the Yaroslavl Local History Museum. The work proceeds slowly and the factory remains an intrusive and ecologically dangerous presence.

Each of Yaroslavl's surviving seventeenth-century churches is a significant work of art. Regrettably, certain conservation efforts seem to have regressed as at the Church of St. Nicholas Mokry (1665–1672) and its companion winter church, dedicated to the Icon of the Tikhvin Mother of God (1686), both of which had additional ceramic ornament added in the 1690s. Much of that ornament has been preserved, but the grounds of the churches look like a disaster area, with apparently abandoned construction materials littering the overgrown space between them. The neighborhood, however, is being refurbished with an infusion of private funds, and I had the impression that influential supporters would see to the restoration of this ensemble.

In the country surrounding Yaroslavl, the revival of religious institutions as a force for preserving cultural treasures is demonstrated most impressively at the reopened Tolg Convent (north of the city and near the left bank of the Volga), formerly one of the most venerated monastic sites in Russia. The simple dormitories and extensive vegetable gardens testify to everyday life at the convent, but the great labor and dedication involved in reclaiming the site is most stunningly revealed in the contrast between the renovated churches (figure 55) and the ruined walls of those buildings, including one church, that have yet to be restored. Community support for the convent is impressive, and during our visit we noticed a steady stream of visitors, including groups of school children. The Tolg icon workshop, whose three painters are members of the convent, is increasingly renowned.

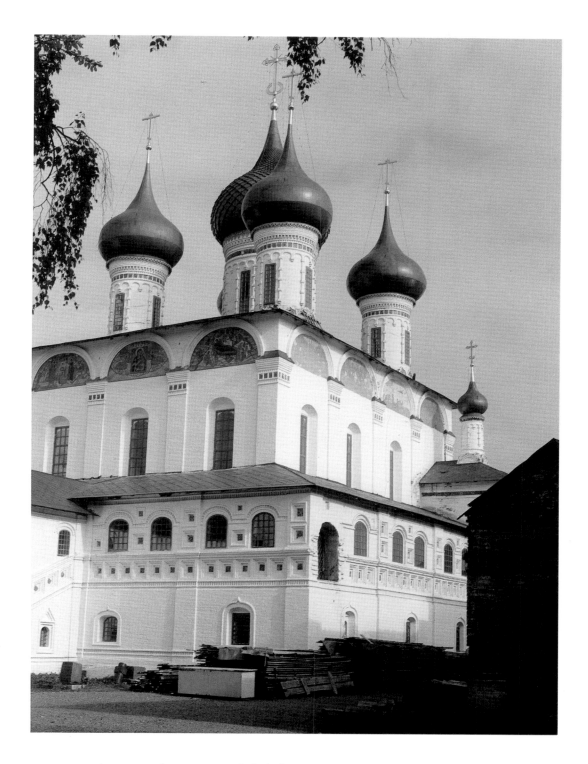

Figure 55. Tolg Convent. Cathedral of the Presentation, southwest view, 1681–1688.

The most curious juxtaposition between between art and religion appeared during my visit to the Resurrection Cathedral at Borisoglebsk, the right-bank district of a Volga River town now called Tutaev. Built in 1670–1678, the church's design rivals the best of Yaroslavl architecture (figure 56). When a representative from the Yaroslavl mayor's office and I arrived at the church, it appeared to be closed, and the priest had left for the day. A young man in vaguely monastic garb was working on a pile of lumber in the courtyard, and we approached him. He seemed to hesitate when we asked about entry into the church. I dismissed the matter and was photographing the exterior when he returned and said that the church would be opened for us, but I was not to photograph a miraculous icon.

I had not anticipated the force of the frescoes, which give this church its reputation for miraculous powers (figure 57). Their colors seem muted in comparison with contemporary work in Yaroslavl itself, but the strength of conception was no less—particularly in the scenes of the Last Judgment on the west wall. I could still see the powerful incisions in the wall surface that guided the composition of scenes such as the righteous bathing in the waters of heaven.

While I began to photograph as unobtrusively as possible, we were greeted by a woman tidying the interior, who began a small sermon on Orthodox belief for my companion, Tatiana, who was a recent convert to Orthodoxy. I was particularly struck during this monologue by the repeated assertion that the church's frescoes needed no special preservation, because they had a miraculous power of self-renovation and cleaning. I finished several general shots and asked Tatiana if she could retrieve my tripod for more detailed work. As she returned, another woman—elderly but vigorous—burst in and said that I was forbidden to photograph without the permission of the priest. We left.

Someone later explained to me that two factions existed at the Resurrection Cathedral: one (including the young man) that believed this church in particular should reach the

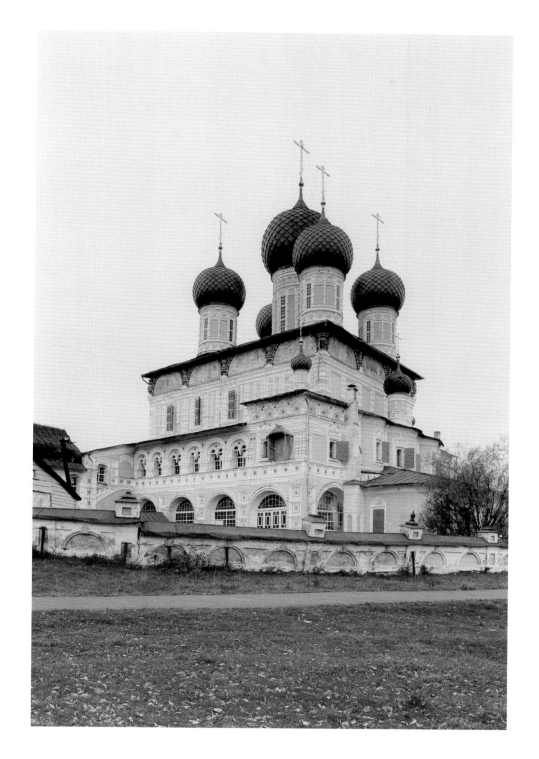

Figure 56. Borisoglebsk (Tutaev). Cathedral of the Resurrection, southeast view, 1652–1678.

∿

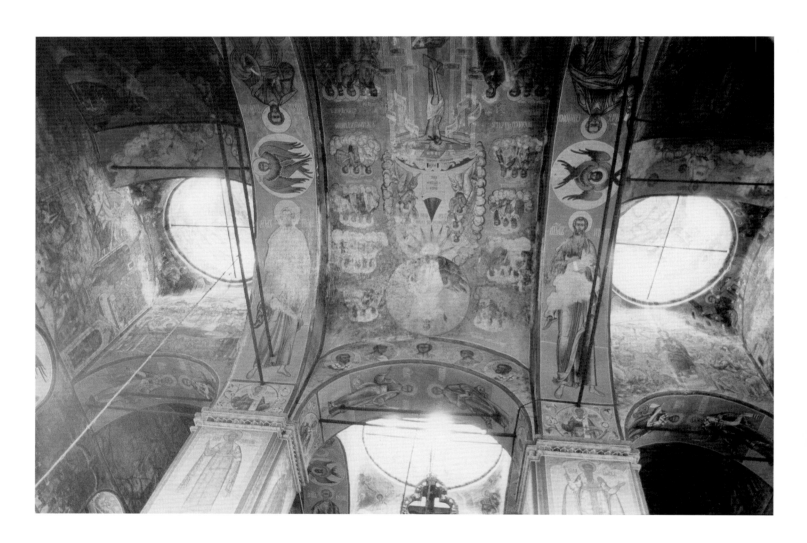

Figure 57. Borisoglebsk. Cathedral of the Resurrection, interior.

wider community with the aid of icons and frescoes, and another that insisted on the need to carefully guard the church's mysteries and miracles. If this was in fact the case, then my encounter at Borisoglebsk reflected a larger struggle for direction within the Russian Ortho-dox Church during a time of unprecedented, perhaps unanticipated, change.

If country roads provide one means of entering the Russian heartland, river travel provides another, more distinctive path to traditional Russian culture. Inflation has tempo-rarily lessened the number of Russian tourists along the major networks, much to the dismay of many who consider that access to the country's heritage is no longer affordable for most of its own citizens. Yet the large fleet of river cruisers and hydrofoils still serves as a "bus" system for an area that, when the seasons permit, has often relied on water rather than land to move goods and people.

No river is more deeply embedded in the Russian national consciousness than the Volga, which, with its many tributaries, continues to link most of the centers of Russian culture—past and present—on the European side of the Urals. The routes to the north of Moscow (along the upper Volga and along the former Mariinskii Canal system to the far northern Lakes Onega and Ladoga) provide ideal access to provincial towns rich with archi-tectural monuments such as Uglich, dreamy with the ambiance of the past. Several of its churches extend along the bank of the river, but there is much more inland, including one of the most elaborate seventeenth-century, brick, tower churches: the refectory Church of the Dormition, built in 1628 at the Monastery of St. Aleksii (figure 58). The church was known as the Wondrous (*Divnaia*) for the daring structure and harmony of its three tent spires. They are situated not only over the central cube but also above two flanking chapels on the east end, suggesting a possible symbolic reference to the Trinity. The church arose as part of a rebuilding of the monastery after its sack by Polish invaders during the Time of Troubles, and its bold form can be interpreted as a memorial to national deliverance. Farther north,

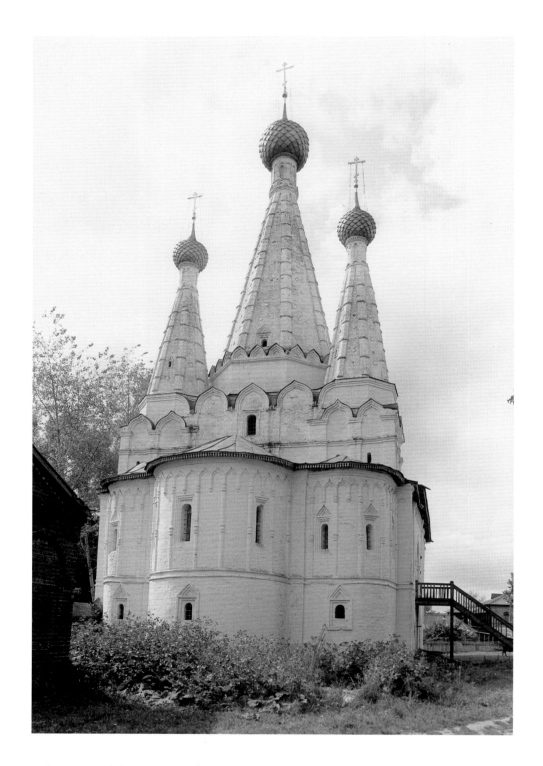

Figure 58. Uglich. Monastery of St. Aleksii, Refectory Church of the Dormition, east view, 1628.

∾

along the old Mariinskii Canal system, are towns such as Kirillov, with its early nineteenth-century ambience and a magnificent seventeenth-century ensemble at the St. Cyril-Belozersk Monastery (figure 59).

As one proceeds northward along the river network, the forest environment becomes ever more impressive, as does the architecture created from it. For most of Russian history, wood has been the abundant material for virtually every style of structure, including churches, dwellings, and fortifications. Fire and decay have long since destroyed the work of early medieval Russian carpenters, but much of the best surviving work has been gathered into open-air museums.

The oldest examples of Russian wooden architecture are churches, which were used more carefully than houses, and which could last as long as three to four centuries—provided rotting logs were promptly replaced and the roof maintained (figures 60, 61). Little has been preserved from before the eighteenth century, and attributions of log churches to the fifteenth and sixteenth centuries are extremely rare. Whatever the problems of chronology and evolution, it has been possible to establish a typology of such structures, from small churches that resemble the shape of the peasant house, to elaborate tower churches composed of ascending octahedrons.

The supreme expression of the genius of Russian wooden architecture is the tiered Church of the Transfiguration of the Savior on Kizhi Island, at the northwest part of Lake Onega (figure 62). Built in 1714 ostensibly in honor of Peter the Great's victories over the Swedes, a Transfiguration Church had existed at Kizhi since at least the early seventeenth century. Like St. Basil's in Moscow, the impression produced by the Kizhi Transfiguration is one of profusion and complexity; yet the design is the very essence of logic—tectonic and aesthetic. Located on open space in the southwest part of the island, the church formed the center of a *pogost*, a term which by the eighteenth century had come to mean an enclosed

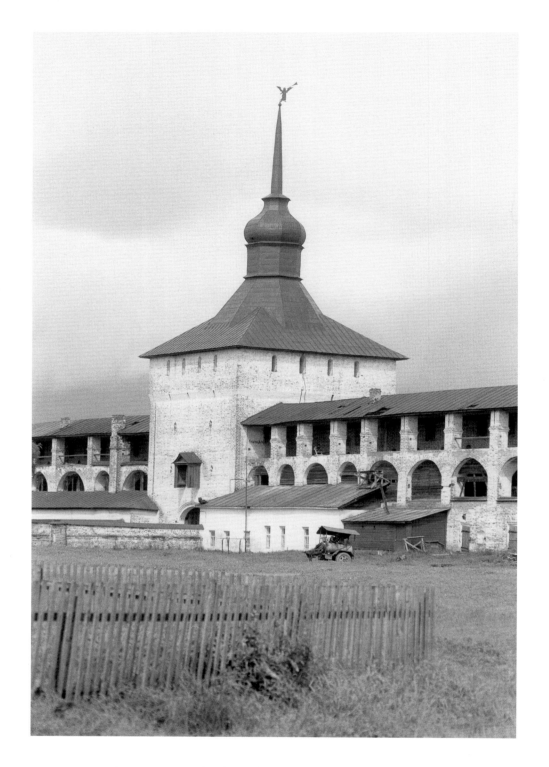

Figure 59. St. Cyril-Belozersk Monastery, Kazan Tower, 17th century.

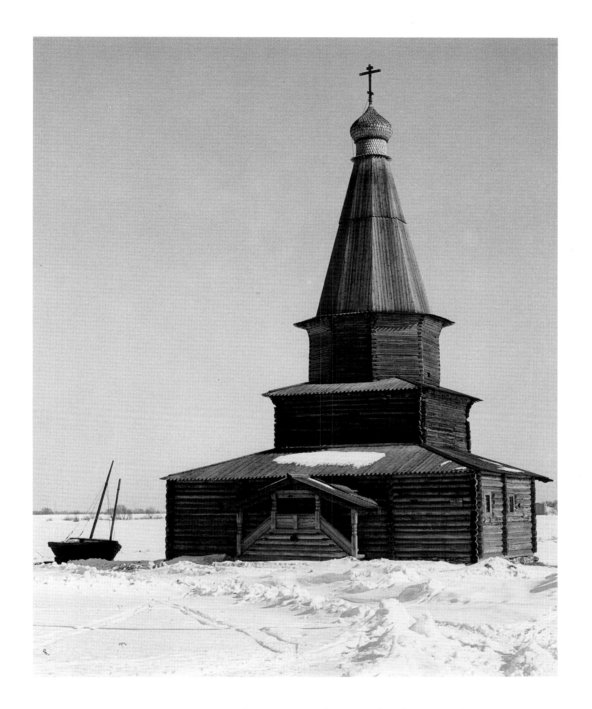

Figure 60. Novgorod. Church of the Dormition, from Kuritsko village, west view, 1595.

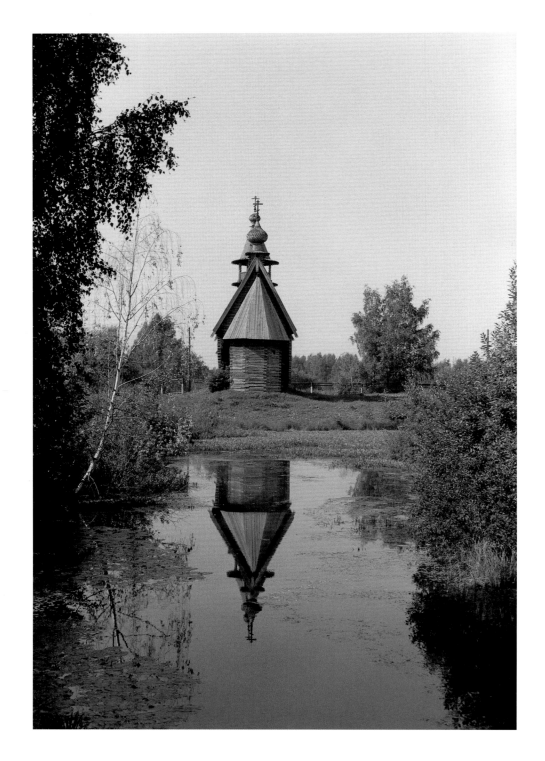

Figure 61. Kostroma. Church of the Dormition, from Fomiskoe village, east view, 1721.

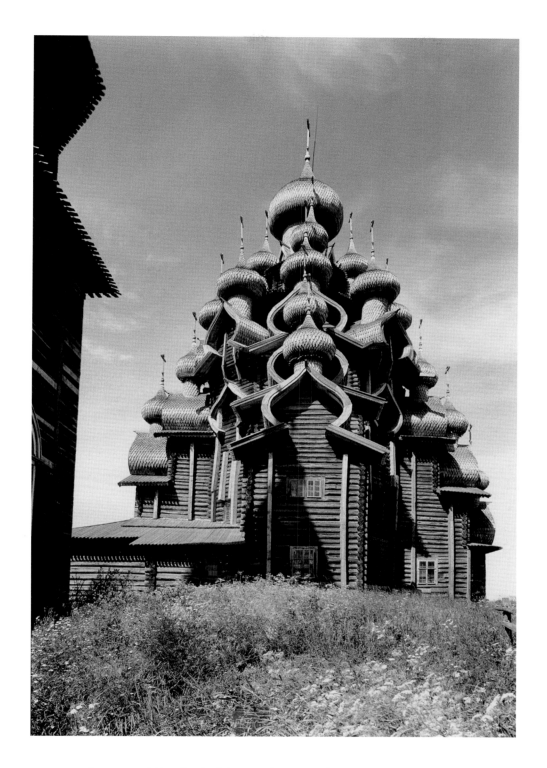

Figure 62. Kizhi. Church of the Transfiguration of the Savior, south view, 1714.

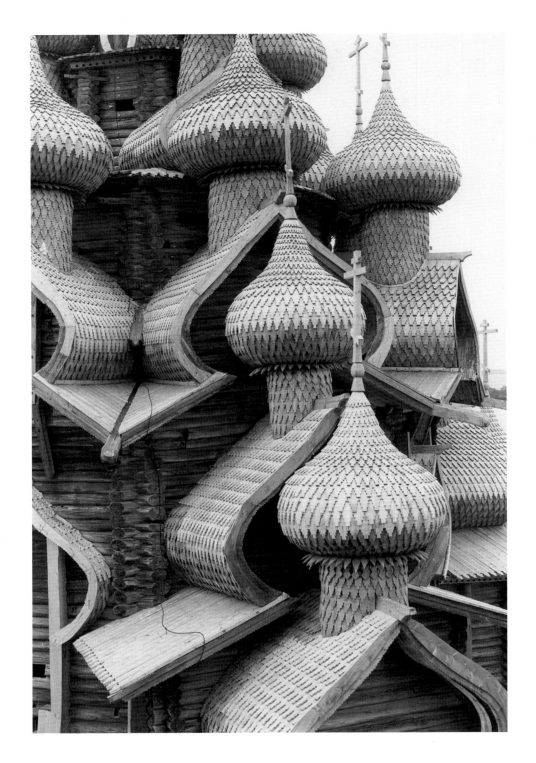

Figure 63. Kizhi. Church of the Transfiguration, cupola detail.

cemetery with a parish or district church. Its high pyramidal silhouette (thirty-seven meters) signified consecrated ground from a great distance, and the design of the structure reinforces at every point that symbolic purpose.

The core is an octahedron in three tiers, buttressed on the lowest—and largest—tier by rectangular extensions at the four compass points. These extensions are also stepped, and thus each of the four provides two additional *bochka* (barrel) gables surmounted by a cupola. The eight cupolas of these extensions merge with eight above the main octahedron, and four more surmount the next octahedron. The final octagonal tier supports the culminating, largest cupola, and the twenty-second cupola rests over an unobtrusive apse extending from the east. The harmony created in this intricate pattern of cupolas and structure is capable of extended analysis, so varied are the impressions that it produces. The natural properties of materials are fully exploited for aesthetic effect in the contrast between the dark walls of aged pine logs and the brilliant silver of the cupolas, covered with a total of some thirty thousand, curved, apsen shingles with stepped points (figure 63). This elaborate superstructure provided an efficient system of ventilation to preserve the structure from rot; yet it was not visible from the interior, which was capped at a low level by a painted ceiling, or "sky" *(nebo)*, over the central part of the church. Apart from the religious imagery of the iconostasis, the interior walls were unpainted.

The Church of the Transfiguration was used only during the brief northern summer. It was not uncommon in Russian settlements to have paired churches, for summer and winter. At the Kizhi *pogost*, the adjoining "winter" Church of the Intercession, built in 1764, provides an admirable visual complement to the ensemble. While the Transfiguration soars, the Intercession accentuates the horizontal, with an extended vestibule that could be used for community meetings (another feature of many northern wooden churches).

I first saw the Transfiguration Church on a blustery, overcast August day in 1988, when fall was already in the air. The low clouds imparted to the island the brooding poetry

of the northern Russian landscape, and my photographs of the Kizhi log buildings brought out the texture of the wood without sharp lighting contrasts. On my second trip to Kizhi, however, in August 1991, I hoped for better weather—in vain, it seemed at first. Shower clouds scudded across Lake Onega throughout the day; but as we approached Kizhi in the afternoon, the sky cleared in patches and the water in the inlets became eerily smooth, the color and appearance of obsidian. When the ship docked at four o'clock, the cloud banks were still heavy and the thunder ominous; but the wind favored us and the clouds drifted south. The air was scented of meadow grass, and sunlight began to play on the aged pine logs of the Church of the Transfiguration. One works for decades in hope of such a moment. The transformation was complete.

The light grew richer, and with such unexpected luck (surely deserved), I used film more quickly than anticipated. A dash back to the ship produced more film; but as I returned to the island, three Aeroflot helicopters appeared overhead. They landed and suited delegations disembarked—definitely not a summer crowd. Outdated walkie-talkies crackled as the group accompanied a short, pudgy man with glasses and a short haircut: Valentin Pavlov, prime minister of the Soviet Union, who had arrived on the island for a photo op. (The following day *Pravda* announced that Pavlov was on a three-day trip to Karelia to visit local leaders and to discuss with Finnish authorities the "unsatisfactory" situation in Soviet-Finnish trade. Two weeks later, Pavlov would participate in the eight-man junta attempting to seize power from Mikhail Gorbachev.)

Approaching the south ensemble of churches, I noticed that something unusual had occurred with the light, and I hurried forward with jolting cameras, only to find my way blocked by a plainclothes state security agent. I had no choice but to retreat to the north. The navigator of the ship had come ashore to watch the spectacle, and he offered to accompany me around the north part of the island, with its own small churches (figure 64) and a small year-round community. We got back to the dock with only a few minutes to spare.

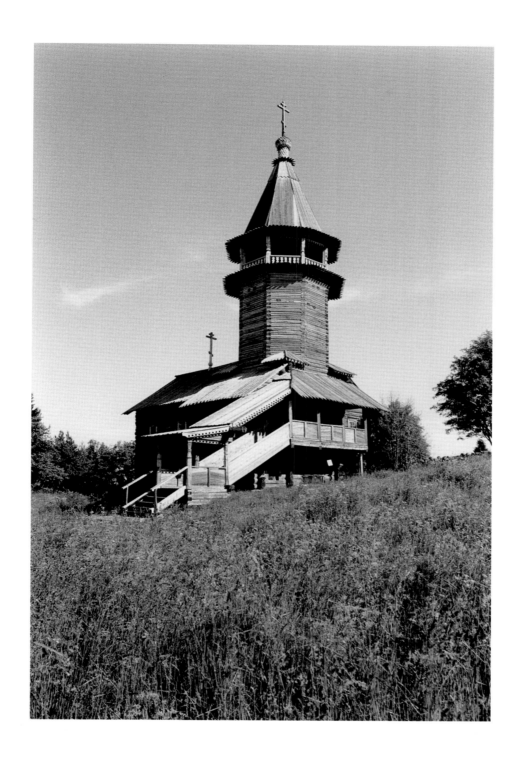

Figure 64. Kizhi. Chapel of the Three Prelates, northwest view, 18th century (?).

The main churches on the south, he told me, would be spectacular from the upper deck of the boat as we left. But nothing could have prepared me for this final, giddy turn of events: at eight o'clock, our ship edged into the channel, and at the same moment, the delegation helicopters took off with a roar. I looked in the direction of the Church of the Transfiguration: its darkened log walls and shining cupolas had become radiant as the light of the sun, low on the horizon, struck the surface directly.

Unfortunately, this crown jewel of a church is in danger of collapse, as bureaucratic indecision has thwarted the implementation of all but the most immediate repairs. Large beams have been fastened to the main segments of the walls; and while they do not obscure this most spectacular of wooden churches, they blatantly signal the need for emergency, stop-gap measures to preserve the structure—a metaphor for Russia itself after the collapse of Communism.

MEDITATION ON THE RUINS

In surveying the devastation inflicted upon the treasures of Russia's historic architecture, one confronts not only the specific history of that country, but also complex, perhaps universal, questions about changing social values and the rise and fall of cultures. Every country has its ruined architectural landmarks, the product of wars, accidents, and the vicissitudes of time. In some cases these ruins have been enshrined and poeticized, as in Clarence J. Laughlin's photographs of Louisiana plantation mansions, the "ghosts along the Mississippi." In Europe, as well as in the United States, classical and medieval ruins have long been a staple of romantic genre painting. We do not, however, like to acknowledge that the devastation of history's legacy has often been the product of our own century. In western Europe, the great majority of ruins produced by the Second World War have either been effaced or rebuilt at great cost. And the ruins created by urban redevelopment have disappeared under new buildings.

In Russia, by contrast, anyone who deviates even slightly from the usual tourist routes will come upon blatant evidence of neglect and cultural vandalism extending to secular as well as religious monuments. And most of this can be attributed to the political upheavals of the twentieth century. In many cases the relation is indirect, the result of mis-

guided urban renewal projects or of demographic shifts from country to city, which would have led inevitably to the abandonment of many country churches, not to mention estate houses.

Yet more complex issues can be found in the preservation, or neglect, of historic architecture. In some cases such monuments as large eighteenth-century country churches are testimony to caprice on the part of the local patron, whose support of ostentatious church architecture occurred with little interest in the well-being, spiritual or material, of the surrounding community which consisted largely of enserfed peasants. Does this indifference to the condition of other humans justify, perhaps "poetically," the destruction of monuments created out of injustice?

The dichotomy between art and social justice is as old as recorded civilization, and if we were to condemn architecture for the moral turpitude of its patrons, very little would survive from the Renaissance. Indeed, why should a double standard be applied to Russia, of condemning the artifacts of a culture because of a rejection of the society that created it? And yet I suspect that this standard is applied toward the history of Russian architecture, both among Western historians as well as among many Russians themselves.

In this regard I found it telling that our driver, who navigated backcountry roads with such intelligence and skill in the autumn of 1992, should have more than once objected to my enthusiastic appreciation of some grandiose ruin of a country church. Why was this church ever built, he asked? Who needed this display of luxury? It would have been far better had these resources been devoted to economic development, to the raising of the general standard of living, etc. For Viktor the ideal was the white frame church found in every New England village, or the Russian log churches, created by and for a local community.

Such an approach has much to recommend it in the abstract, but it says nothing about the actual conditions in which Russian church builders worked—or, for that matter, about the culture of Russian Orthodoxy. Why should these churches, whatever their ori-

gins, be condemned to vandalism? Their artistic meaning for subsequent generations in those villages could have been entirely positive. Behind Viktor's attitudes lay, I suspect, a measure of guilt and shame at the extent of the destruction, and the likelihood that little could be done to correct it.

Public response to architectural preservation differs widely, and in the present economic crisis, the earlier system of projects selected and supported by the state can hardly be sustained. Whatever the sense of urgency, money has its own way of deciding the issue. In the new era, individuals and private institutions such as the church must provide the impetus for saving the country's architectural heritage. How they will do that at a time when the value of the ruble falls even as it drops into the collection boxes is very much an open question.

One specialist with long experience in preservation issues told me that during the late Soviet period, allocated funds were sufficient only for about 10 percent of the registered monuments in need of restoration. Now there is not even a third of that amount. With so many other priorities—and with so much fraud and waste—it is difficult to believe that the decline of architectural monuments will not continue on a considerable scale. The photographer can only work with what time and fate have left. Yet there are those moments of revelation, on a snow-covered field at Bogoliubovo, beneath a transfigured summer sky at Kizhi.

REFERENCES

Batiushkov, K. N. "Progulka po Moskve." *Sochineniia*. Moscow: Iskusstvo, 1934.

Borisov, Nikolai S. *Okrestnosti Iaroslavlia*. Moscow: Iskusstvo, 1984.

Briusova, Vera. *Freski Iaroslavlia XVII-nachala XVIII veka*. Moscow: Iskusstvo, 1983.

Brumfield, William C. "Anti-Modernism and the Neoclassical Revival in Russian Architecture, 1906–1916." *Journal of the Society of Architectural Historians* 48 (December 1989): 371–86.

———. "Photographing Russian Architecture." *Visual Resources* 5 (1989): 259–88.

———. "The Color Photographs of Sergei Mikhailovich Prokudin-Gorskii." *Visual Resources* 6 (1990): 243–55.

———. *The Origins of Modernism in Russian Architecture*. Berkeley: University of California Press, 1991.

———. "Frozen Moments: Notes of a Photographer in Russia." *Ideas* 1, no. 2 (1993): 12–23.

———. *A History of Russian Architecture*. New York: Cambridge University Press, 1993.

Cohen, Jean-Louis. *Le Corbusier and the Mystique of the U.S.S.R.* Princeton: Princeton University Press, 1991.

Dobrovol'skaia, Ella and Boris Gnedovskii. *Iaroslavl'. Tutaev*. Moscow: Iskusstvo, 1981.

Dolgova, S. "Prodolzhat' pechataniem zapreshcheno." *Literaturnaia gazeta* 9 (1993): 7.

Eding, Boris von. *Rostov Velikii. Uglich*. Moscow: I. Knebel, 1913.

Elliott, David. *Photography in Russia: 1840–1940*. London: Thames and Hudson, 1992.

Fedosiuk, Iurii. *Moskva v kol'tse Sadovykh*. 2nd edition. Moscow: Moskovskii rabochii, 1991.

Fedotova, Tatiana. *Vokrug Rostova Velikogo*. Moscow: Iskusstvo, 1987.

Formozov, Aleksandr. "Pervyi russkii istoriko-arkheologicheskii zhurnal." *Voprosy istorii* 4 (1967): 208–12.

———. *Pushkin i drevnosti*. Moscow, 1979.

Gun'kin, G. I. "Tserkov' v podmoskovnom sele Bykove." In *Pamiatniki russkoi arkhitektury i monumental'nogo iskusstva*, edited by Vsevolod Vygolov, 121–39. Moscow: Nauka, 1994.

～

Kozlov, Vladimir. *Kolumby rossiiskikh drevnostei*. Moscow: Nauka, 1981.

—————. "Tragediia Kitai-goroda." *Moskovskii zhurnal* 2 (1992): 16–26.

Laughlin, Clarence. *Ghosts along the Mississippi*. New York: Scribner's, 1948.

Pod"iapol'skaia, E. N. *Pamiatniki arkhitektury moskovskoi oblasti*. 2 vols. Moscow: Iskusstvo, 1975.

Romaniuk, Sergei K. *Iz istorii moskovskikh pereulok*. Moscow: Moskovskii Rabochii, 1988.

—————. *Moskva. Utraty*. Moscow: Tsentr, 1992.

Ruble, Blair A. "Reshaping the City: The Politics of Property in a Provincial Russian City." *Urban Anthropology* 21 no. 3 (1992): 203–33.

Slavina, Tatiana. *Issledovateli russkogo zodchestva: Russkaia istoriko-arkhitekturnaia nauka XVIII-nachala XX veka*. Leningrad: Leningrad State University, 1978.

Smirnov, Ivan. *Viaz'ma—Starinnyi russkii gorod*. Moscow: Moskovskii rabochii, 1988.

Zubarev, V. V. "Khram-rotonda v sele Podmoklovo." In *Pamiatniki russkoi arkhitektury i monumental'nogo iskusstva*, edited by Vsevolod Vygolov, 108–22. Moscow: Nauka, 1991.

INDEX

William Craft Brumfield is Professor of Slavic Studies

at Tulane University. A master photographer, he has pursued his

interest in Russian architecture for over twenty years. He is the author of

several books, including *A History of Russian Architecture*, *Origins of*

Modernism in Russian Architecture, and *Gold in Azure*.

Library of Congress Cataloging-in-
Publication Data

Brumfield, William Craft, 1944–
Lost Russia: photographing the ruins of Russian
architecture / William Craft Brumfield.
p. cm.
Includes bibliographical references.
ISBN 0-8223-1557-2. ISBN 0-8223-1568-8 (pbk.)
1. Lost architecture—Russia (Federation)—
Pictorial works. 2. Architecture—Russia (Federa-
tion)—Pictorial works. I. Title
NA1181.B75 1995
720´.947 DC20 94-23065
CIP

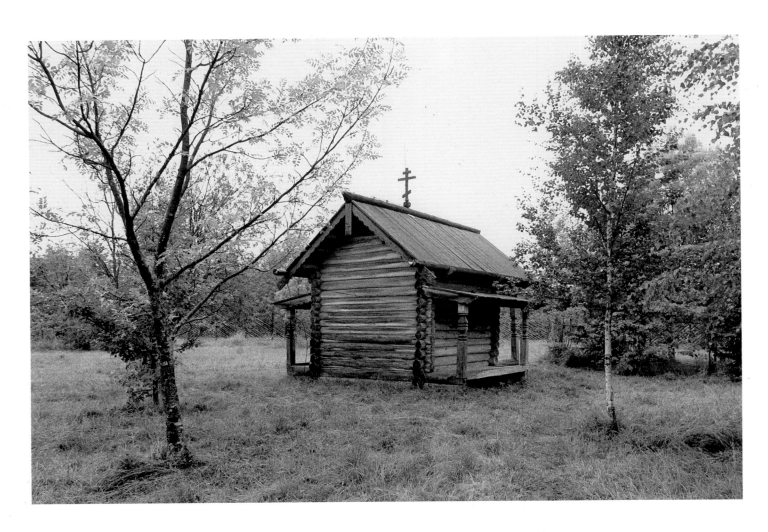

Chapel from village of Gar (near Novgorod), late 17th century (?).